IMA
of Am
NEW

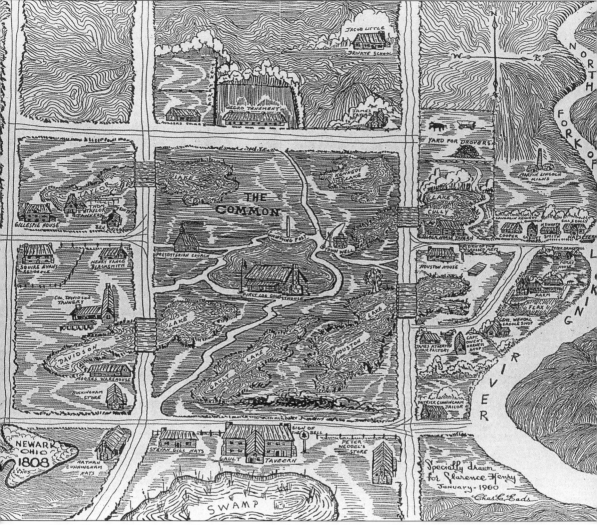

THE CITY OF NEWARK. This drawing is a layout of the city of Newark. The first courthouse was made of logs, was square, had no floor, and contained slab seats. It was built around 1809. In 1815, a second courthouse was erected and was two stories high and built of brick. Around 1832, a third building was erected with two stories of brick and the third of wood. It was destroyed by fire in 1875. The cornerstone of the present courthouse was laid on July 4, 1876.

IMAGES
of America
NEWARK

Chance Brockway

ARCADIA

Published by Arcadia Publishing
Charleston SC, Chicago, IL, Portsmouth NH, San Francisco, CA

Printed in Great Britain

Library of Congress Catalog Card Number: 2004108747

For all general information contact Arcadia Publishing at:
Telephone 843-853-2070
Fax 843-853-0044
E-mail sales@arcadiapublishing.com
For customer service and orders:
Toll-Free 1-888-313-2665

Visit us on the internet at http://www.arcadiapublishing.com

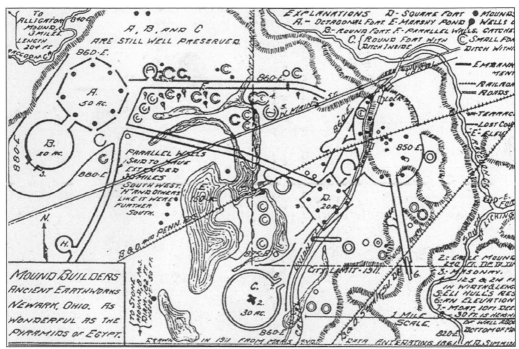

ANCIENT EARTHWORKS AT NEWARK, MOUND BUILDERS CITY. The number, magnitude, and uniformity of these elaborate and gigantic earthworks of Mound City mark them as among the most complete in North America. They were constructed without the use of iron or any other useful metal. They are as mysterious as the pyramids of Egypt, and they are strong evidence that here once lived and struggled a great people. A people with a religion, a government, and with a knowledge of agriculture.

CONTENTS

ACKNOWLEDGMENTS

John Weaver had a great idea—and this is it—a book of historical photographs of Newark, Ohio. Volunteers made this book possible. I donated the use of historical photographs. My daughter, Sondra Brockway Gartner did the design, layout, and computer work required. Special thanks to Connie Rutter of Hudson Avenue for sharing the research she has done on Newark and Licking County. And thanks to Emily A. Larson who provided captions and photographs from the Licking County Historical Society. John Weaver's foreword provides a heartfelt introduction.

Thanks to Arcadia Publishing, who has over 1500 titles in their *Images of America* series. They print, sell, distribute, and promote the book and pay royalties on the profits, which in this case will go directly to the Licking County Historical Society.

I would like to dedicate this book to the memory of two good friends of Newark, Ohio: C.W. "Bud" Abbott, collector of historical photographs and postcards of Newark and Licking County, and William E. Davis, authority on Newark history who had plans to publish a book that would have been titled "Newark Ohio 1801–1900." A tragic automobile accident prevented the book from being finished. Hopefully, the descendants of Bud Abbott and Bill Davis will preserve the historical material accumulated during their lifetime and make it available for future study and review.

—Chance Brockway

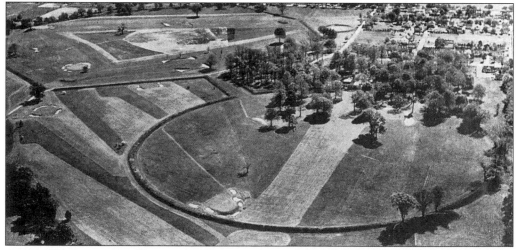

ARIAL VIEW OF THE OCTAGON MOUND AT THE NEWARK EARTHWORKS. The ancient earthworks, or Mounds, in Newark are classified as number 34 in the list of 300 wonders of the world.

INTRODUCTION

The first settlers came to what was to become Newark, Ohio at the beginning of the 19th century. Colonel Schenk platted the area, which the Fairfield County Commissioners approved in 1802. Schenk, who was from Newark, New Jersey, chose that name for the new community.

His plan provided a town square with very wide streets, which would allow wagon trains to turn around with ease. Many early towns grew up along both sides of an important road. However, Newark was laid out in a grid pattern around the square, which provided for orderly growth.

The development started as a farming community, which became rich from the products of the soil and had large surpluses. In 1825 the Erie Ohio Canal was commenced. With its completion new markets were opened for grains, which moved both north to the East Coast and south down the Mississippi. This made the farmer the most prosperous settler in the area.

Then came the locomotive. Not only did the farmer benefit, but opportunities also came in the railroad maintenance shops (roundhouses); telegraph operators and blacksmiths were needed, and numerous other jobs developed. The Civil War years were boom times. The following years produced substantial growth. Rope, cigars, steam engines, furnaces, wagons, trucks, automotive parts, tires, glass containers, glass tableware, fiberglass, aluminum, lawn mowers, chemicals, quartz, lighting fixtures, golf clubs, fishing lures, bows and arrows, furniture, packaging materials, and plastics were produced, and continue to be, by a dedicated and productive work force. To this day Newark is a lively area with a great deal of varied industrial and commercial activity.

This pictorial history of Newark begins, obviously, with the development of photography. The earliest pictures date to the late 1840s and feature the four sides of the downtown square. Other aspects of Newark featured include the canal, railroads, churches, schools, fire and police departments, housing, industry, people, and parks.

The genius of this collection is Mr. Chance Brockway, a long time sports photographer and collector of historic pictures. In numerous pictures his enlargement techniques show details, which can easily be overlooked, and add real flavor to the collection. We are grateful to him for his dedication to bring this most interesting collection into a very worthwhile book about our Newark, Ohio.

—John H. Weaver
Past President, Licking County Historical Society
Newark, Ohio

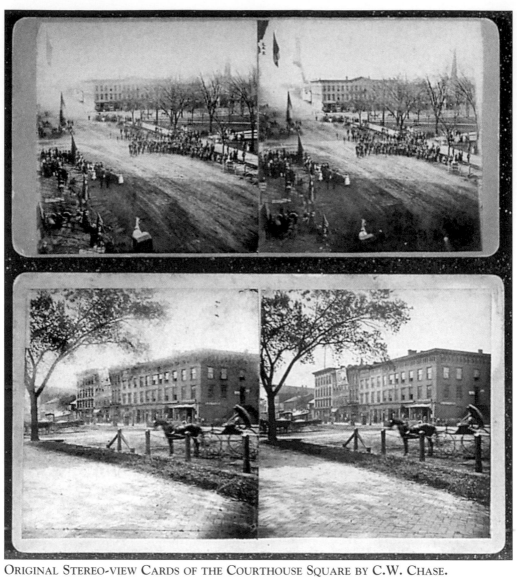

Original Stereo-view Cards of the Courthouse Square by C.W. Chase.

One

AROUND THE SQUARE

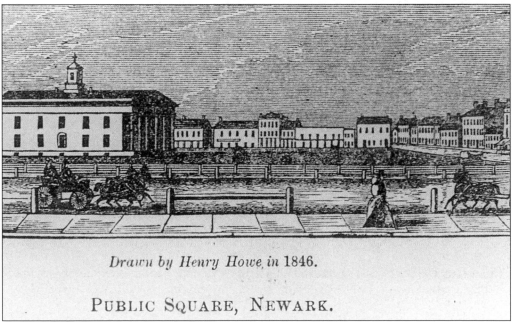

Drawn by Henry Howe, in 1846.

PUBLIC SQUARE, NEWARK.

DRAWING OF PUBLIC SQUARE, 1846. The Courthouse of today sits in the center of the Square. It was built in 1876–78, with H.E. Meyer of Cleveland as architect. The Courthouse was placed on the National Register of Historic Places in 1973. The building is regarded as one of the finest Second Empire-style courthouses in Ohio. The Courthouse clock tower rising above the mansard roof was first lighted around 1928 as part of the national "Jubilee of Light," celebrating Edison's invention of the incandescent lamp. The lighting consisted of vertical stringers of white bulbs from the top of the tower to the ledge just above the roof. A crown of light bulbs surrounded the peak. This effect was maintained year-round for several years. The stringers were removed, and the tower was dark during the period of World War II. It wasn't lit again until 1948 when colored lights were used, creating an instant hit with everyone.

The buildings around the Square in the early 1800s are in contrast to the scene of the Square today.

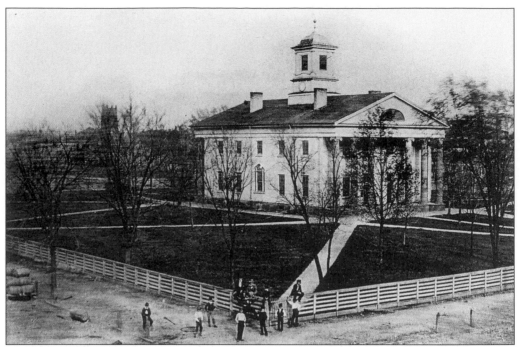

THE COURTHOUSE BEFORE 1874. The Courthouse before the fire of 1874 was surrounded by a wide lawn and fenced in by a board-hitching rail. The Courthouse Square was the center of civic pride in the early days with its tree-shaded velvety green lawn. Note the dress of the men of the day in the bottom portion of the photograph.

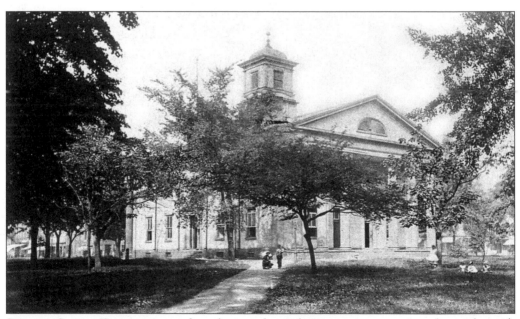

SUMMER SCENE. Youngsters rested on the courthouse lawn on a warm summer day in the mid-1800s. The county's third courthouse is visible in the background.

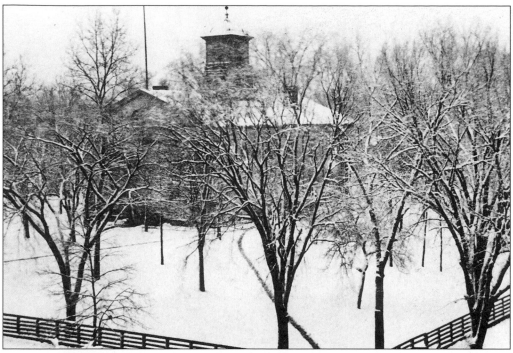

THE COURTHOUSE LAWN IN WINTER. This is how the Licking County Courthouse lawn looked on a wintry day in the mid-1800s. Note the wooden fence and the relatively small size of the trees.

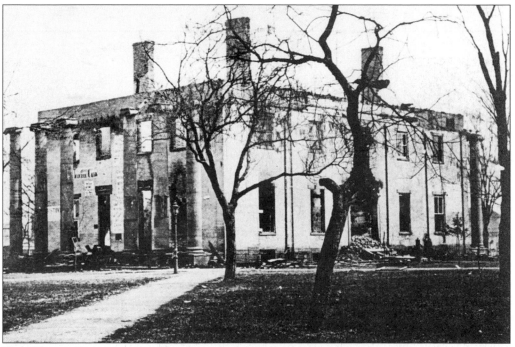

THE THIRD COURTHOUSE. The county's third courthouse, built in 1832, was destroyed by a fire April 3, 1875. The structure was considered to be obsolete, and little sorrow was caused by its destruction.

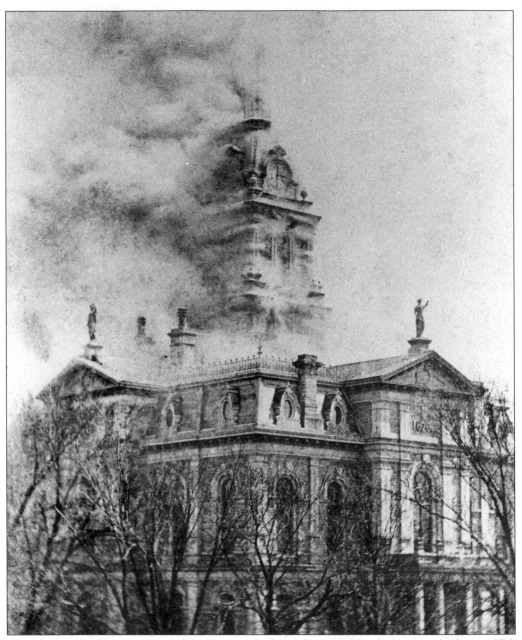

THE CURRENT COURTHOUSE. The current Licking County Courthouse was built in 1876, costing $190,000. It was described as fire proof, "except for the upper portions." Those upper portions caught fire in 1879, causing $50,000 in damage. Records of the county auditor and county recorder were destroyed. A defective flue was blamed.

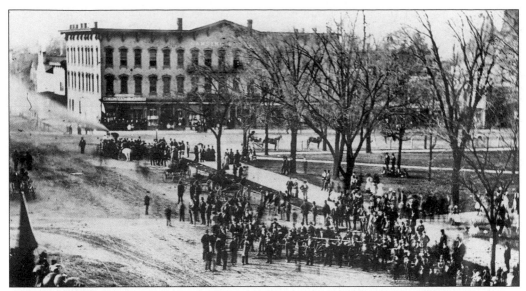

FIRE FIGHTING EQUIPMENT AROUND THE SQUARE. Newark acquired its first fire engine, a steamer, visible at the extreme left in the background. Other fire apparatus were also on display. The fire fighting equipment passed the test if they could shoot water as high as the tallest buildings. Note the dirt streets and the hitching posts along the sidewalks.

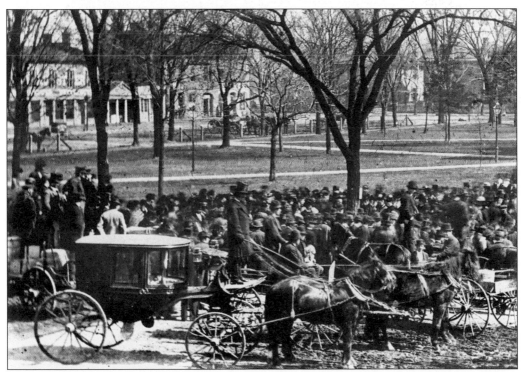

TESTING FIRE DEPARTMENT EQUIPMENT. This photograph shows the west end of North Park Place in the background and the west lawn of the Licking County Courthouse. Fire Department equipment is being tested before purchase.

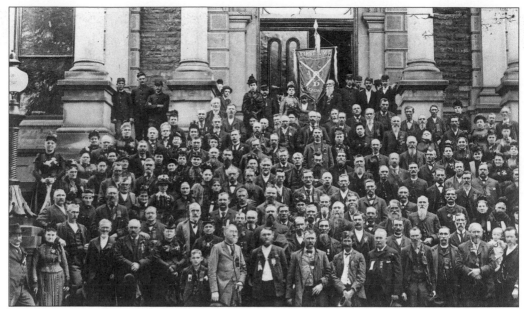

VETERANS ON THE COURTHOUSE STEPS. Licking County Union Army veterans gathered on the Courthouse steps during a reunion they held around 1896. Some of the people pictured may be survivors of the Battle of North Mountain. This little-known Civil War action, which took place in northeastern West Virginia, decimated a Union Army recruited from Licking County and tragically impacted numerous families left behind.

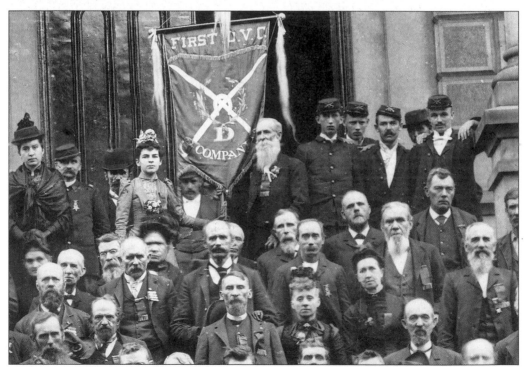

THE VETERAN'S BANNER. This enlargement of a portion of the previous photograph shows the Veteran's Banner and dress of the day.

Two
NORTH SIDE OF THE SQUARE

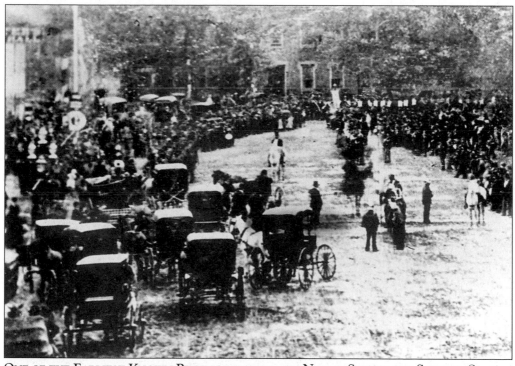

ONE OF THE EARLIEST KNOWN PHOTOGRAPHS OF THE NORTH SIDE OF THE SQUARE. Starting at the northwest side of North Park Place, a two-story log building occupied the corner of the lot. From this log building, running eastward to the alley, was a board fence. Between that point and the northeast corner of Second Street and North Park Place were Stephen Gill's hat shop, Buckingham's store, a brick building, and David Moore's warehouse. The warehouse was a two-story frame building on the site where the Midland Theater now stands.

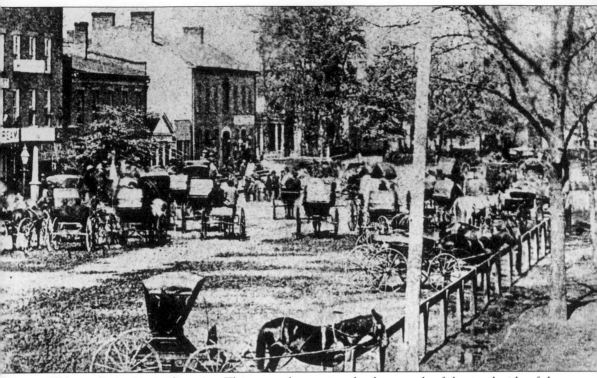

NORTH SIDE OF THE SQUARE. This is another very early photograph of the north side of the Square. Note the hitching rail and the number of horse drawn carriages.

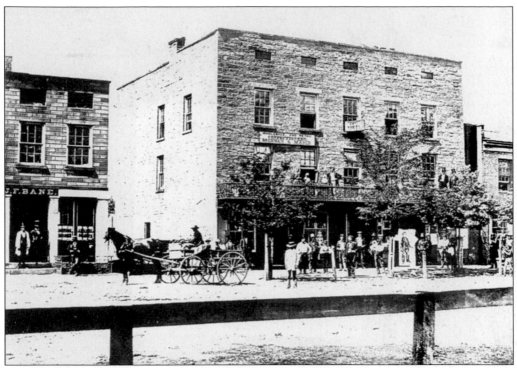

THE CORNELL BUILDING BEFORE ELECTION DAY. This photograph was taken in front of the historic Cornell Building on the day before Abraham Lincoln was elected president of the United States.

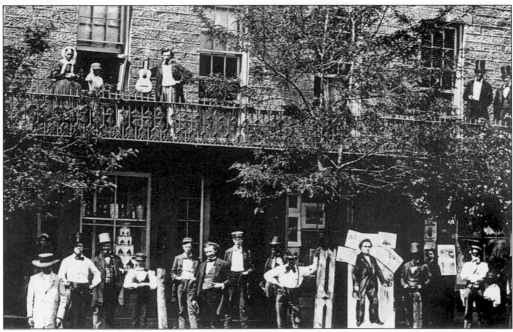

FAMILY POSING ON THE BALCONY. Note the man with guitar and his family posing for a photograph while standing on the balcony of the second floor of the Cornell Building.

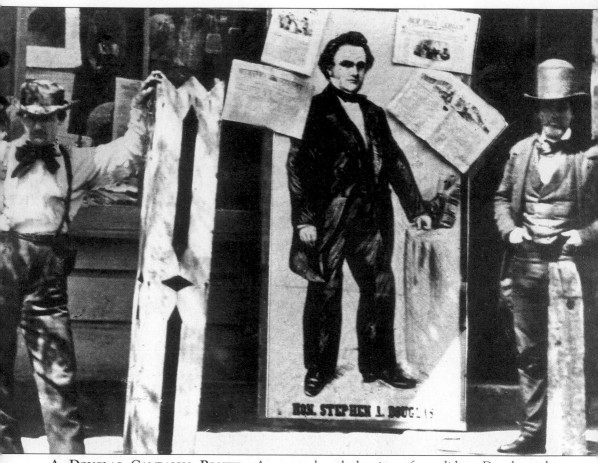

A DOUGLAS CAMPAIGN POSTER. A poster board drawing of candidate Douglas, who campaigned against Abraham Lincoln, stands in front of the Cornell Building, which housed a confectionery and a saloon in the 1860s. Lincoln won by only one vote in Newark but won by a large margin in the county.

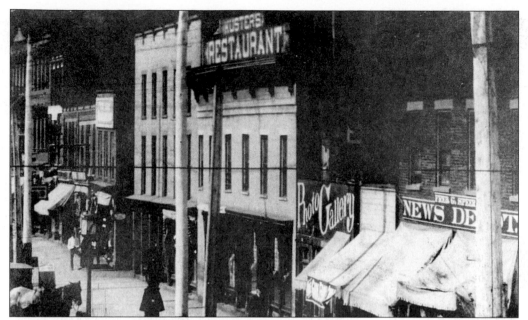

KUSTER'S RESTAURANT. Kuster's Restaurant on North Park Place was one of the famous downtown eateries in the 1900s. Kuster's Restaurant was famous for its giant-sized buckwheat cakes, country sausage, and the Licking County maple syrup. Those were the days when a gallon of syrup could be bought for 75¢. Other specialties were spareribs and sauerkraut, "roast possum," and yams. The Kuster place also was popular with stage folks because of its convenience to the theater. When the stage company was too large to be accommodated at the Warden Hotel, the overflow found sleeping room above the restaurant.

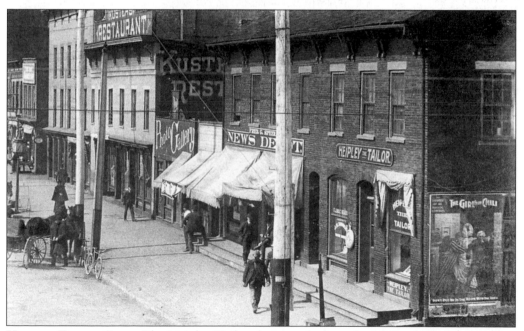

HEIPLEY TAILOR SHOP. The Heipley Tailor shop stood where the Midland Theater is today. Note the sign on the wall of the building advertising upcoming silent movies.

19

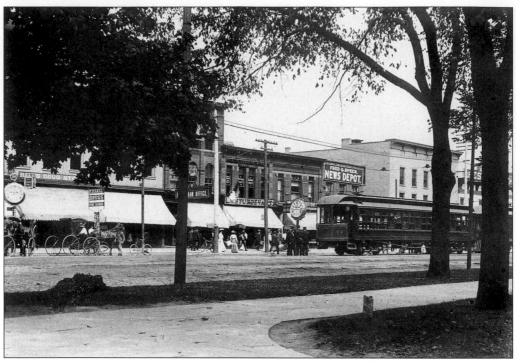

NORTH PARK PLACE. Note the horse drawn carriages and dress of the day.

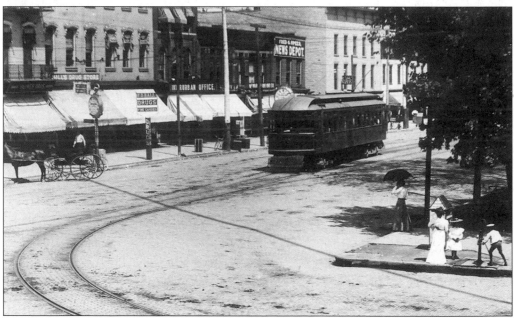

ANOTHER VIEW OF NORTH PARK PLACE. Note the people on the corner waiting for a ride on the Interurban run by the Columbus-Buckeye Lake-Newark Traction Company.

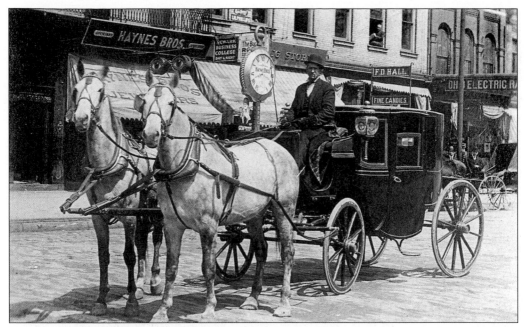

The Hackney Carriage. This "hackney coach or carriage" was used to carry passengers from the train station to the local hotels. Note the "Newark Business College" behind the carriage.

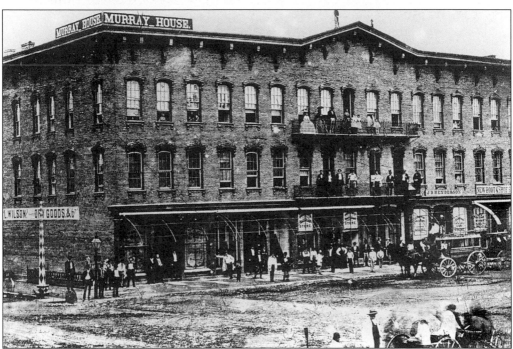

North Third and North Park Place. This photograph, taken in the 1870s, is of the corner of North Third and North Park Place. The Murray House was a complex that housed a variety of businesses on North Park Place, including J.D. Henderson Grocery and Produce Store and the New Boot and Shoe Store at the far right. Wilson's Dry Goods was on the corner. Note the people in the Murray House standing on the balconies and in open windows.

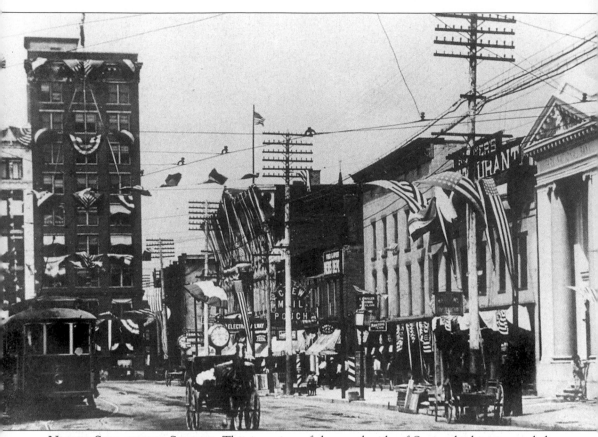

NORTH SIDE OF THE SQUARE. This is a view of the north side of Square looking toward the Newark Trust Building.

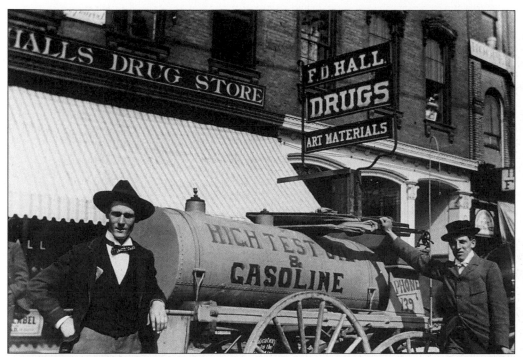

HALLS DRUG STORE. This is a photograph of the site of Halls Drug Store, located on the north side of the Square.

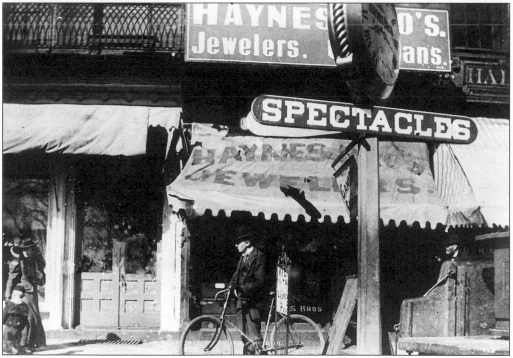

HAYNES JEWELERS. This is the site of Haynes Jewelers, owned by Ray Haynes, located on the north side of the Square.

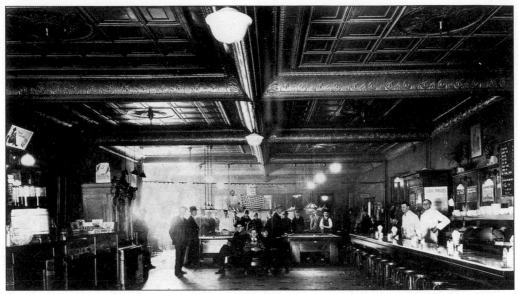

THE BAZAAR BILLIARD PARLOR. This photograph is of the interior of the Bazaar Billiard Parlor. Note the ornate tin ceiling and light fixtures.

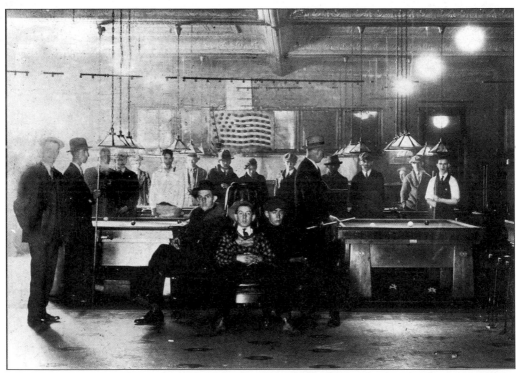

BILLIARD PLAYERS. This enlargement of the photograph shows the local fellows enjoying a game of pool.

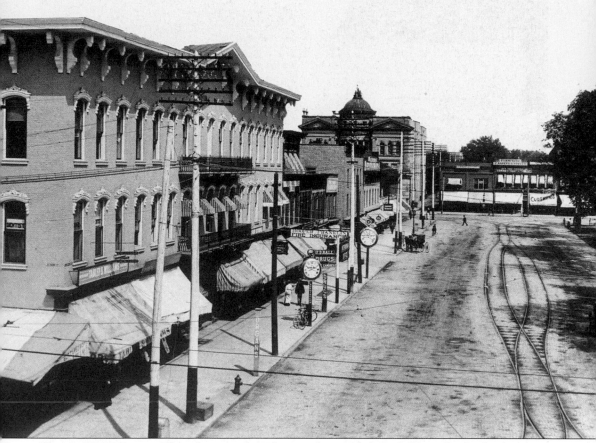

NORTH PARK PLACE. This photograph looks east along North Park Place. In the far distance, just to the left of the street, is the old façade of the Auditorium Theater. The trees of the Courthouse Square are to the extreme right, and you can detect some old trolley tracks in the center of the street.

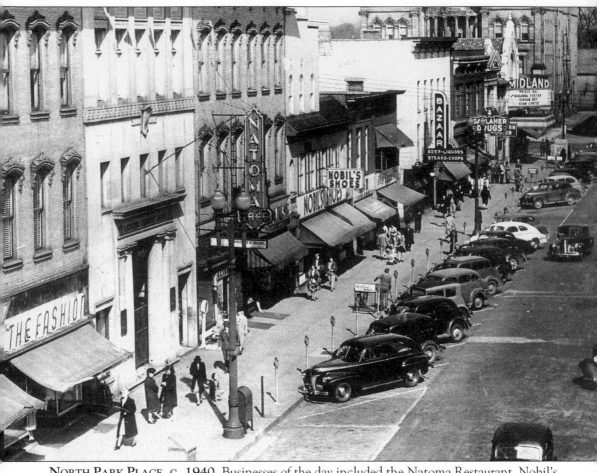

NORTH PARK PLACE, C. 1940. Businesses of the day included the Natoma Restaurant, Nobil's Shoes, the Bazaar, and, at the end of the block, the Midland Theater.

Three
EAST SIDE OF THE SQUARE

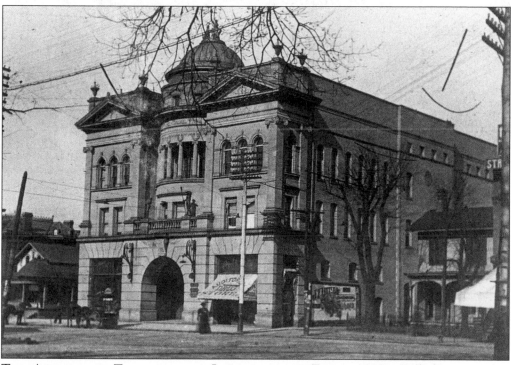

THE AUDITORIUM THEATER AS IT LOOKED IN THE EARLY 1900S. Built by a veterans committee and funded with a $50,000 tax levy, the Auditorium was host to many music hall greats. On the east side of the Square where Auditorium Theater (Memorial Hall) stood, a tavern was kept by Maurice Neuman. Subsequently, the site was occupied by the home of S.D. King, the lawyer, and then the Memorial Building. Taylor's Store was situated on the East Side and was a one-story frame building. Southerly was a row of shanties, extending to the Black Horse Tavern on the corner of East Main and Second Streets. On the site now occupied by Wendy's Restaurant stood Houston's Tavern, which was also know as the Green House and later the Warden Hotel.

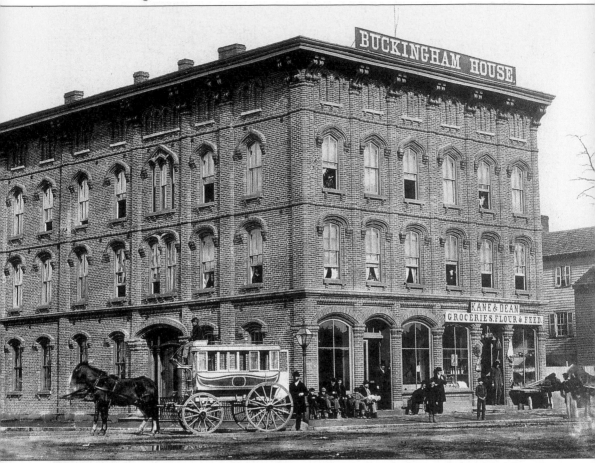

THE BUCKINGHAM HOUSE. Long before the streets were paved, the east side of the Square to the south of East Main Street boasted a proud hotel known as the Buckingham House. The Buckingham House Hotel stood on the corner of South Second and East Main Streets in the 1870s when this photograph was taken. It later became the Warden Hotel.

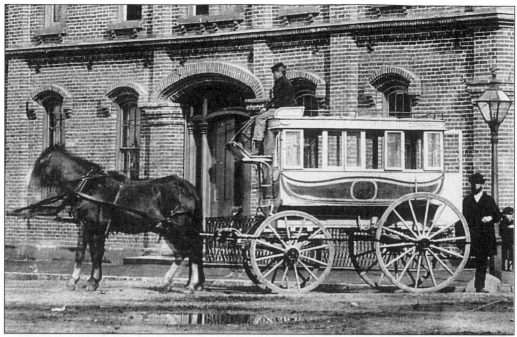

A HACKNEY COACH. Hackney coaches such as this one were used to carry hotel patrons to and from nearby railroad stations. The coach was owned by the Union Livery Stable, located just east of the hotel.

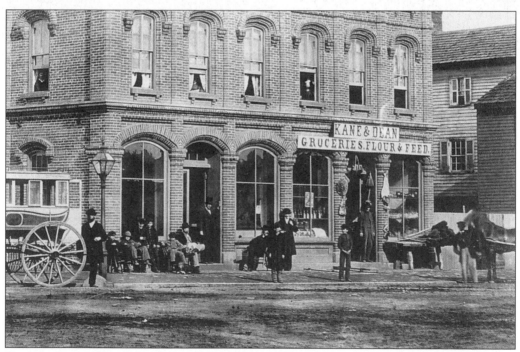

THE KANE AND DEAN GENERAL STORE. This photograph was taken in front of the Kane and Dean General Store. Note the brooms lying on a bench in front of the store. Although the Civil War had ended several years earlier, the style of dress from that era persisted in the 1870s.

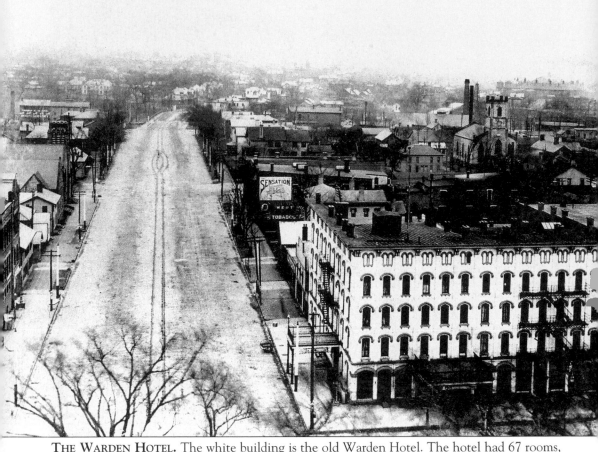

THE WARDEN HOTEL. The white building is the old Warden Hotel. The hotel had 67 rooms, but only 32 had bathrooms. You can see Trinity Church in the background.

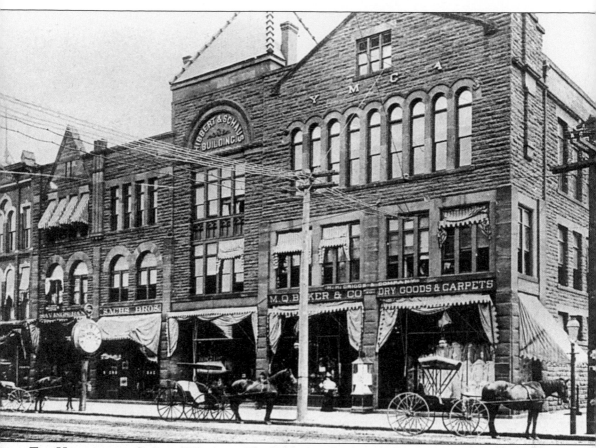

THE HIBBERT AND SCHAUS BUILDING. The Hibbert and Schaus Building stood at Third Street and East Main Street.

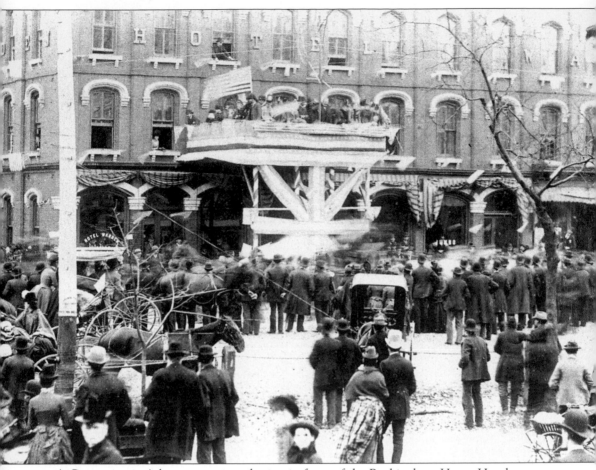

A GATHERING. A large group is gathering in front of the Buckingham House Hotel.

Four
WEST SIDE OF THE SQUARE

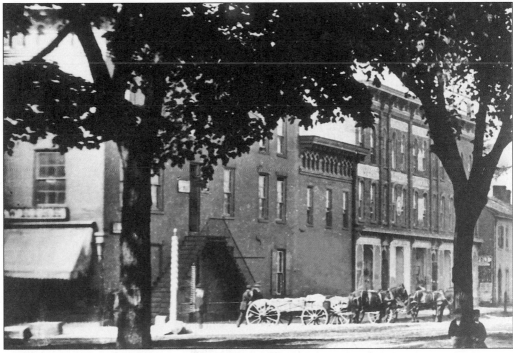

A VERY EARLY PHOTOGRAPH OF THE WEST SIDE OF THE SQUARE AND THE ADVOCATE BUILDING. The west side of the public Square south of West Main Street was occupied by "Lake Davidson." On the northwest corner was Handle Vance's blacksmith shop. Continuing northwestwardly was the American Hotel and Benjamin Brigg's printing office. Here is where the newspaper known today as the *Advocate* was nurtured into being.

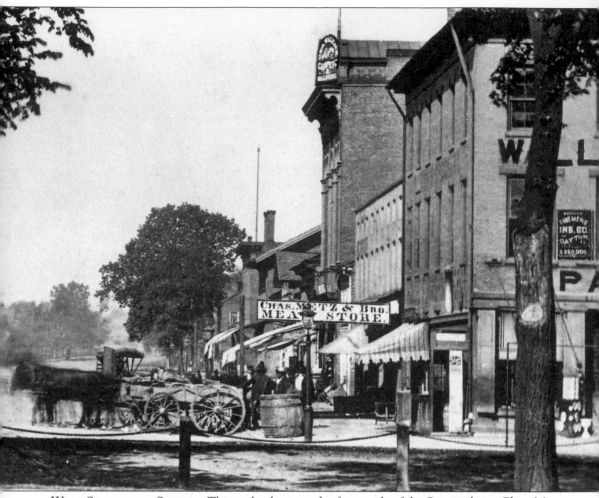

West Side of the Square. This early photograph of west side of the Square shows Chas. Metz & Brothers Meat Store.

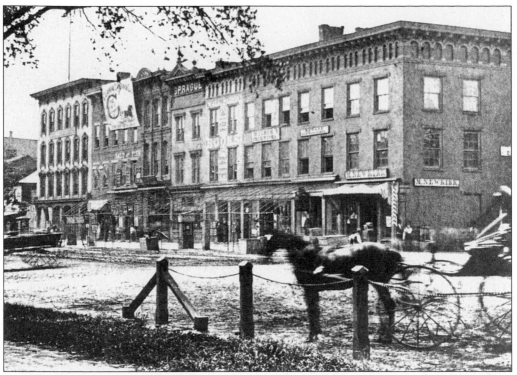

ON THE CORNER. This early photograph is of the corner of Third and West Main Streets.

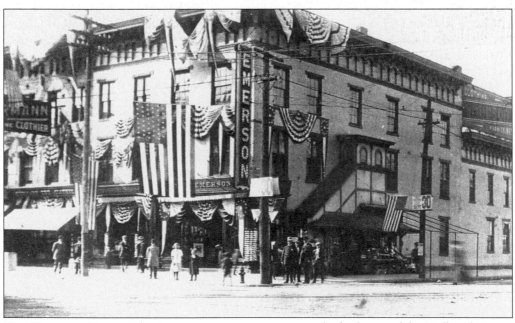

THE EMERSON STORE. The Emerson store was most recently the home of the Hallmark Store.

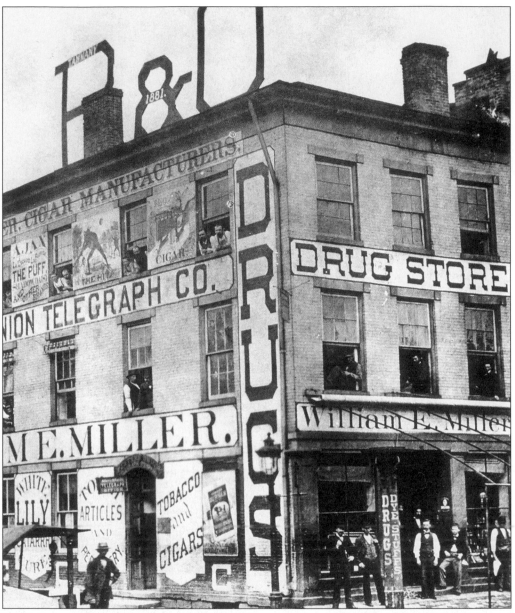

B&O Cigars. B&O Cigars, established in 1881, sat on the northwest corner of West Main and Third Streets.

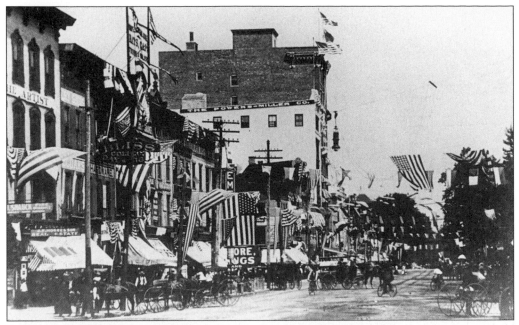

A LARGE CELEBRATION. This is a very early photograph depicting a large celebration around the Square.

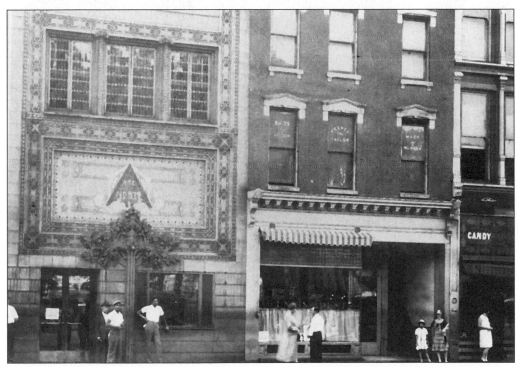

THE HOME BUILDING ASSOCIATION BANK. The Home Building Association Bank building has been entered in the National Register of Historic Places. The building, constructed in 1914, was one of two in Ohio designed by world famous Chicago architect Louis Sullivan. It sits on the northwest corner of West Main and Third Streets.

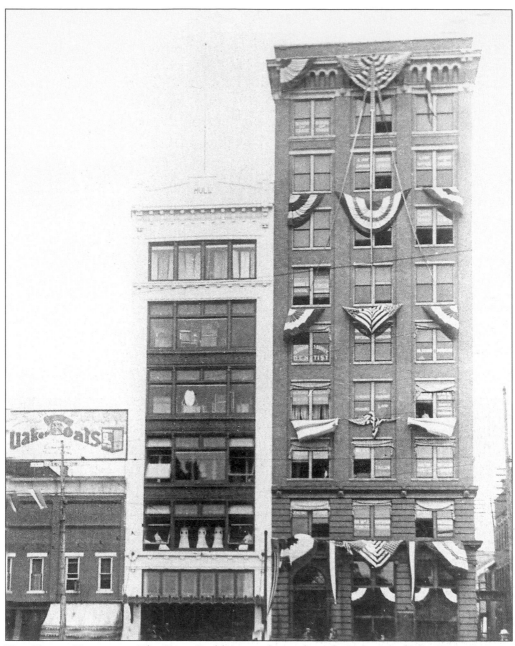

THE TRUST BUILDING. The Trust Building was located on the west side of the Square.

Five

SOUTH SIDE OF THE SQUARE

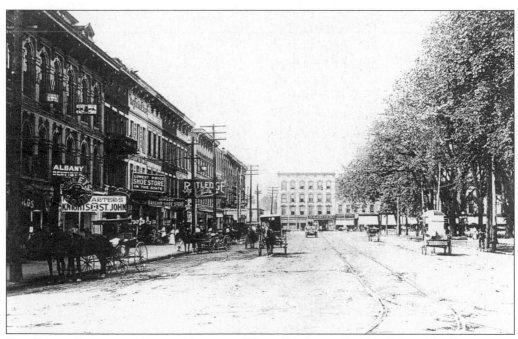

THE SOUTH SIDE OF THE SQUARE LOOKING WEST. On the south side of the public Square were six or seven small frame buildings, as well as Gault's Tavern and P.M. Waddell's store. Some of the articles for sale would be regarded as curiosities today, such as iron candlesticks, lard lamps, gunflints, ginseng, split hickory brooms, and flame-colored calico.

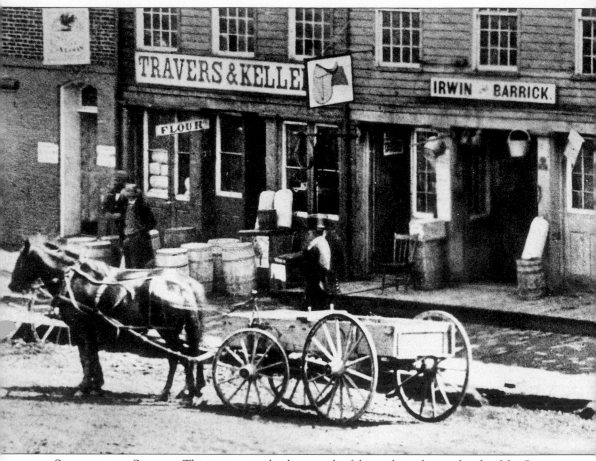

SHOPS ON THE SQUARE. This is a very early photograph of shops along the south side of the Square.

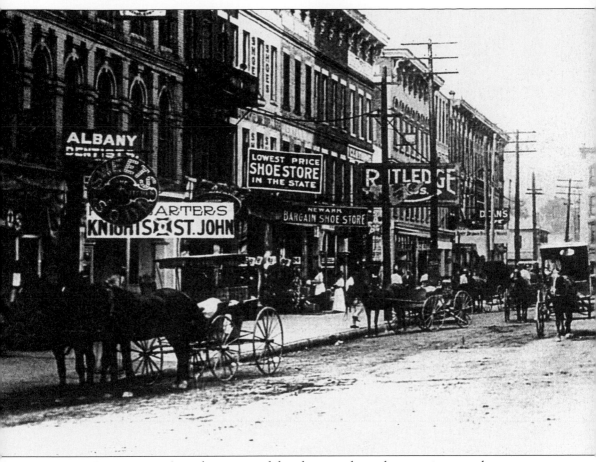

BUSTLING BUSINESSES. An enlargement of the photograph on the opposite page shows many businesses along the street. Note the sign for the "Lowest Price Shoe Store in the State."

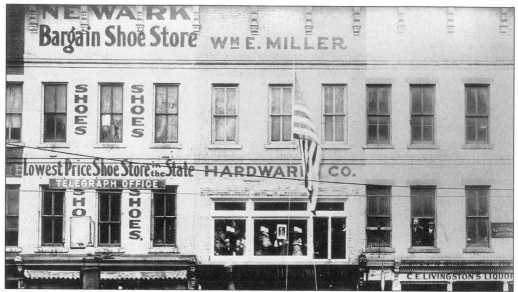

THE DEDICATION OF WILLIAM E. MILLER'S HARDWARE STORE. It was a grand old time on South Park Place as a throng of people turned out, on May 7, 1917, for the dedication of the William E. Miller Hardware Co. Wilmetta and Weldon Dudley, twin sister and brother, raised the flag, shown here, during the ceremonies dedicating their uncle's store. On the left are Newark Bargain Shoe Store and the local telegraph office, and on the right is the C.E. Livingston Liquor Store.

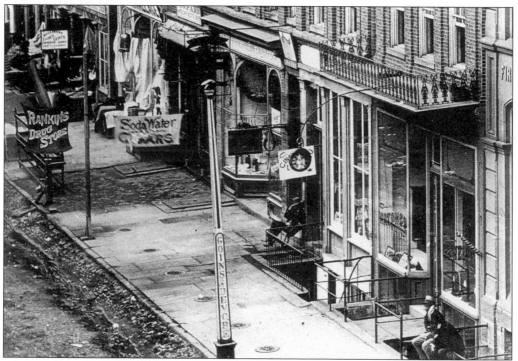

RANKINS DRUG STORE. Rankins Drug Store, featuring "Soda Water & Cigars," was one of many stores along the south side of the Square.

Six

OHIO CANAL

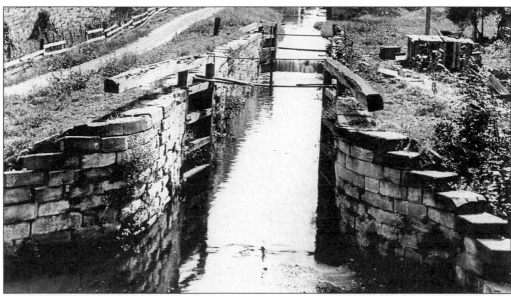

AN EARLY PHOTOGRAPH OF THE CANAL LOCKS. Licking Summit, four miles west of Newark, was the place where the Ohio Canal began. The canal was one of the greatest undertakings of the region's early days. When the settlers cleared their lands and began to really produce crops in the fertile Ohio soil, they raised more than they needed for themselves and began looking around for some place to sell their produce. When the idea of a canal system was first suggested, it spread through Ohio like wildfire. Here was a way for farmers to get their extra products to a market. Before the building of the canal, Licking County had no outlet for produce except by wagons to Lake Erie, or to the Muskingum River and then by boat to New Orleans. Ham was worth 3¢ a pound; eggs, 4¢ a dozen; and wheat, 25¢ a bushel. In February of 1825 the legislature voted for the necessary money for construction of the canal. Things progressed rapidly, and on July 4, 1825, Governor DeWitt Clinton of New York broke the ground at Licking Summit near Newark to start the 307-mile long Ohio Canal. Governor Clinton was the builder of New

York's Erie Canal, which in spite of sneers and predictions of failure, succeeded and was envied by the other states. Since Clinton was the father of the canal system in America, he was invited to turn the first ground at the ceremonies that marked the beginning of construction of the Ohio Canal. On the appointed day, Governor Clinton, Governor Morrow of Ohio, and many other dignitaries of the state and nation, along with other "just plain folks," gathered at Licking Summit (Summit Station) for the day's festivities. The first activity on the program was a big dinner for the invited guests, and for as many others who could afford to pay $1.50. However, many families prepared a picnic basket for themselves since it was cheaper, especially for those with large families. There was much speaking and banqueting, and as the first shovelful of earth was turned, tears ran down the cheeks of many of the spectators, for they realized that the completion of the canal would afford a market for their produce and bring them returns in excess of a mere living. The canal diggers led a rough-and-ready life. During the height of the digging, countless men fell victim to the "fever," or malaria, which was common in Ohio during damp, muggy weather. The diggers were paid 30¢ a day, plus food and whiskey and a shanty. This brought hard cash into Ohio, where barter and trade had been previously used by the frontier people. Canal stops like Newark took on the look of a boomtown, with saloons, rowdy men with cash in their pockets, and makeshift shanty housing. Proper folk looked upon the diggers with little warmth; however, they knew that the men were a necessity and tolerated their wild ways. As the railroads took on more importance and more miles of tracks were laid, the canal gradually began to lose its value. The canal system reached its peak of importance about 1851, then very rapidly declined.

BILL OF SALE. Pictured is a manifest from the warehouse located at South Third Street.

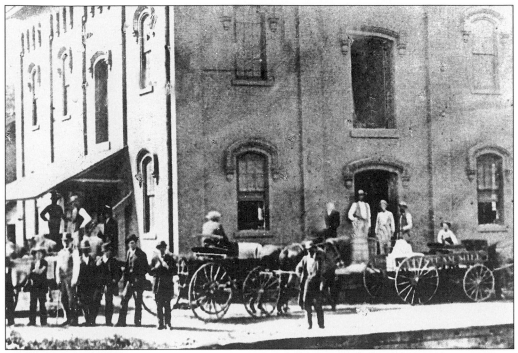

THE WAREHOUSE. This warehouse was located along the canal on South Third Street.

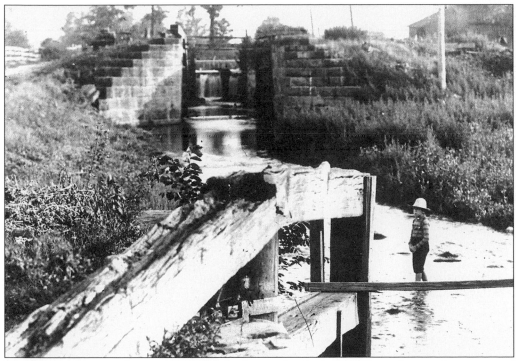

YOUNG BOY AT THE CANAL. A little boy doing what little boys do in the canal near one of the locks.

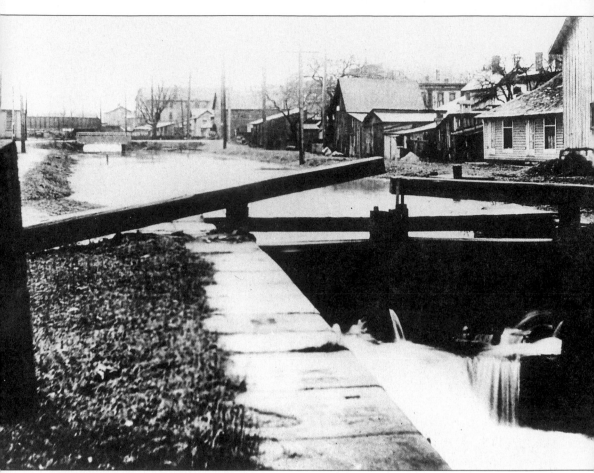

THE OHIO CANAL. The Ohio Canal ran through Newark. This "Port of Newark" played an important part in the western march of civilization, carrying families to new homes, stimulating the growth of settlements and towns, and encouraging commerce.

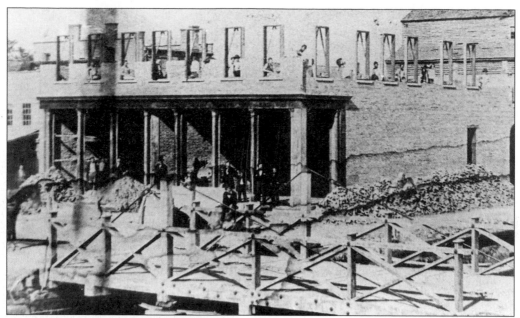

THE OXLEY BROTHERS' FIRM. This photograph was taken in 1858 when the Oxley Brothers' firm was under construction on South Third Street in Newark. Note the temporary wooden bridge over the canal in the foreground and the workers posing at future windows on the second story. This structure was built by Luke K. Warner and Willis Robbins.

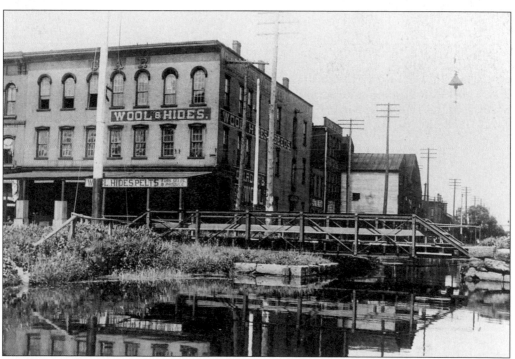

THE OXLEY BROTHERS' FIRM AND THE BRIDGE. This scene shows the present Oxley Brothers building on South Third Street. The bridge was on a pin, which allowed it to turn. The canal has long since disappeared.

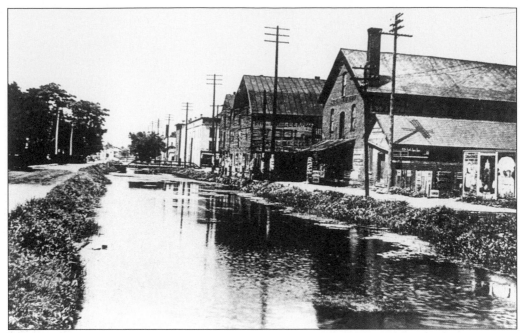

THE CANAL DOCKS. This view of the old canal docks and warehouses between Second and Third Streets was captured by an early photographer. Canal boats loaded and unloaded at docks in this area.

A CLOSE UP OF "GINGER BREAD ROW." Ginger Bread Row was the gathering place for business, fun, and frolic. Saturday of each week was a gala day. On that day many boatmen assembled, mixing with farmers and town people. Ginger Bread Row commenced at the southwest corner of Second and South Main Streets (South Park Place), extending south along Second Street to the canal.

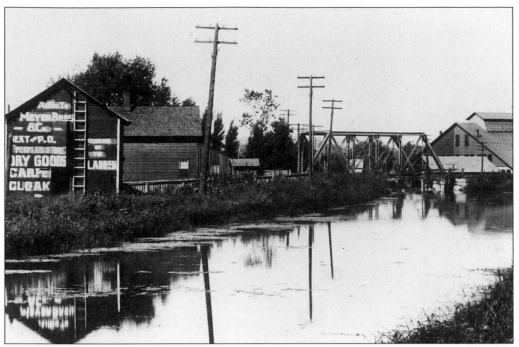

THE RAILROAD BRIDGE. This tranquil summer scene of the canal in Newark looks north towards the Railroad Bridge, which was located near the Roper offices.

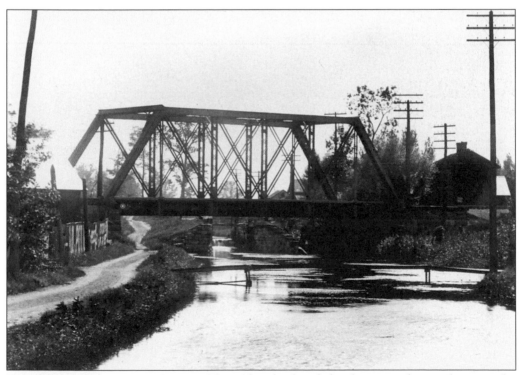

THE RAILROAD AND THE CANAL. The railroads played the decisive role in relegating the canals to history.

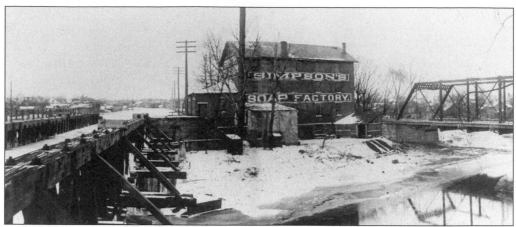

THE SIMPSON'S SOAP FACTORY. The Simpson's Soap Factory was washed out in the Flood of 1898.

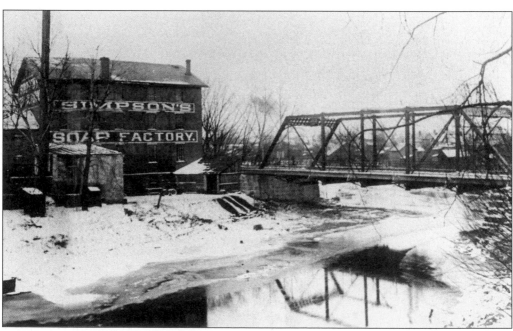

SIMPSON'S SOAP FACTORY AND BRIDGE. This is a close-up view of Simpson's Soap Factory and the bridge over the frozen canal.

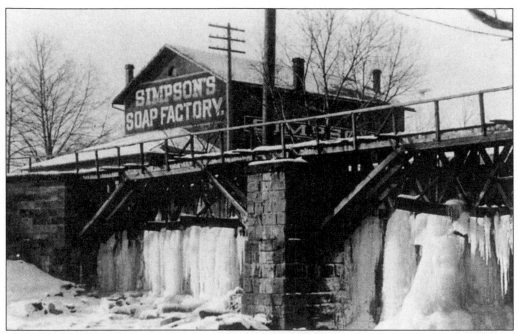

THE AQUEDUCT ACROSS RACCOON CREEK. This is a photograph of the aqueduct on the Ohio Canal across Raccoon Creek, south of the West Main Street Bridge. Heavy chunks of ice reached down to the surface of the creek-bed.

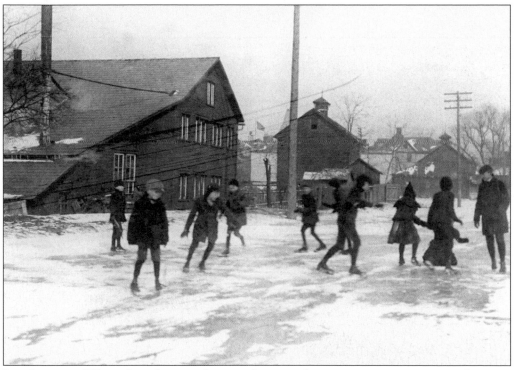

ICE SKATERS. When this photograph was taken, ice skaters were enjoying winter fun near Simpson's Soap Factory, which was located west of Eighth Street in Newark.

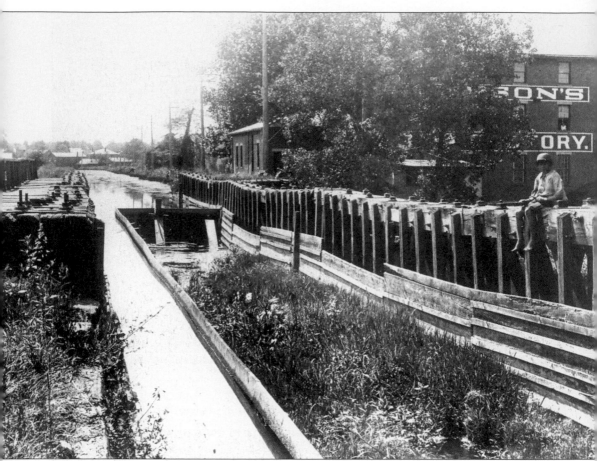

THE AQUEDUCT BY SIMPSON'S. This photograph is of the Ohio Canal aqueduct over the river behind Simpson's Soap Factory.

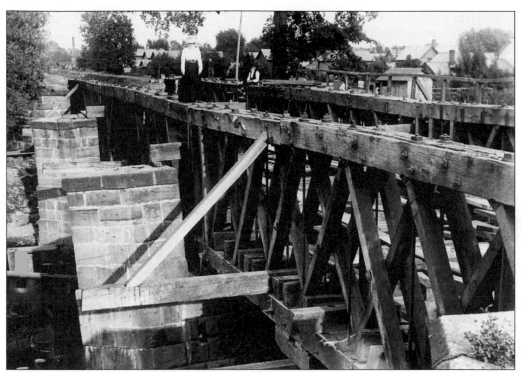

AQUEDUCT SKELETON. This old photograph shows the sagging stone abutments and the skeleton framework of the once stout canal aqueduct at Eight Street, which carried the canal boats across Raccoon Creek. This picture was taken just before the structure was torn down.

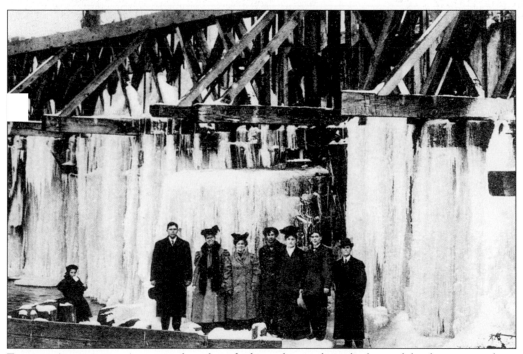

FROZEN AQUEDUCT. A group of unidentified people stands at the base of the frozen aqueduct.

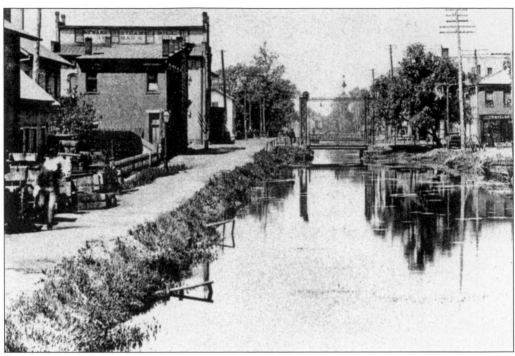

Scene along the Canal.

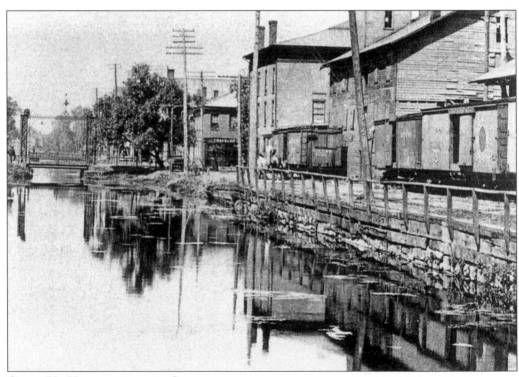

Close Up View along the Canal.

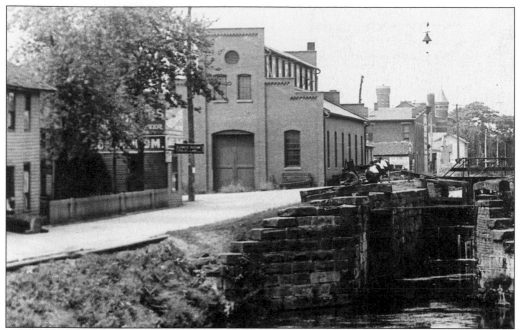

THE LAST LOCK. This photograph is a view of the last-used lock, at Second Street west of the Baltimore & Ohio Depot. No boats entered this lock after the viaduct over the North Fork was washed out in the Flood of 1898, and Ohio Canal traffic in Newark came to an end.

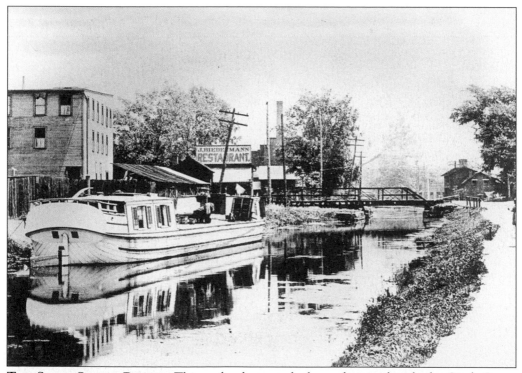

THE SIXTH STREET BRIDGE. This early photograph shows the canal with the Sixth Street Bridge in background.

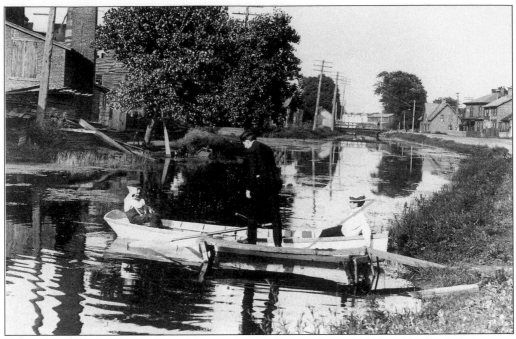

ON THE CANAL. Father and sons enjoy a day on the canal.

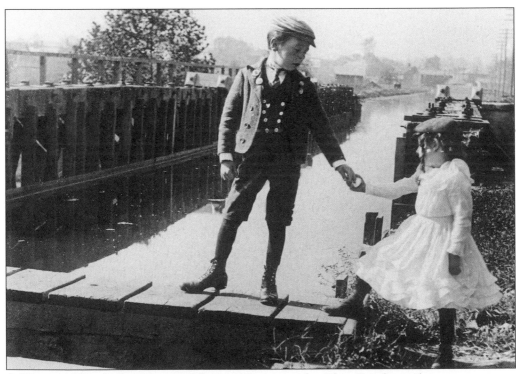

A HELPING HAND. Ray Haynes and sister Mary cross the Ohio Canal aqueduct.

THE ICEHOUSE. This early photograph shows the icehouse situated on Sixth Street.

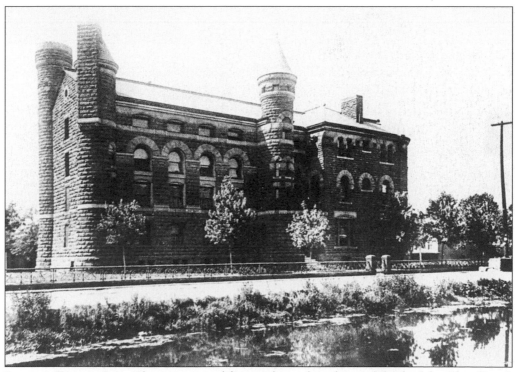

LICKING COUNTY JAIL. This imposing edifice was located on the south bank of the Ohio Canal.

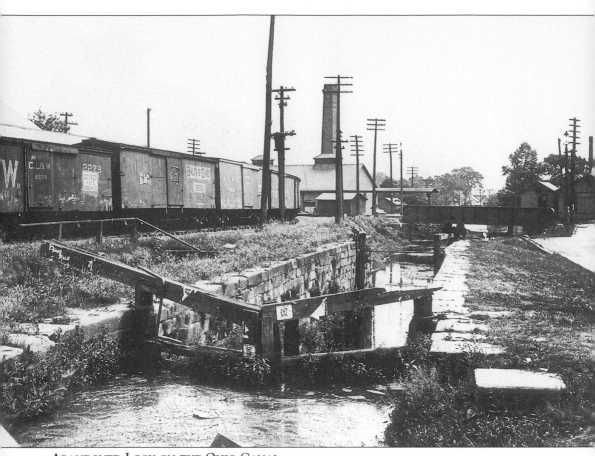

ABANDONED LOCK ON THE OHIO CANAL.

Seven

CHURCHES AND SCHOOLS

According to the Church Directory c. 1840, the following churches were in town at that time:

The Baptist Church was on the east side of Fifth Street between Canal and Main Streets, Reverend A. D. Abbott, pastor.

The Catholic St. Francis de Sales' Church was on the north side of Granville between Fifth and Sixth Streets, "Reverend Frederick Bender, pastor."

The Episcopalian Trinity Church was on the east side of First Street between Canal and Main Streets, Reverend II.B. Ray, pastor.

The Lutheran Evangelical (German) Church was on the west side of Fifth Street south of Walnut Street, reverend unknown.

The Methodist Episcopalian Eastern Charge Church was on the west side of Fourth Street between Main and Church Streets, Reverend A. Carrol, pastor.

The Methodist Episcopalian Western Charge Church was on the north side of Main Street between First and Second Streets, Reverend E. Bing, pastor.

The First Presbyterian Church was on the west side of Third Street between Church and Locust Streets, Reverend Wm. Robinson, pastor.

The Second Presbyterian Church was on the north side of Church Street between First and Second Streets, Reverend H. Humphrey, pastor.

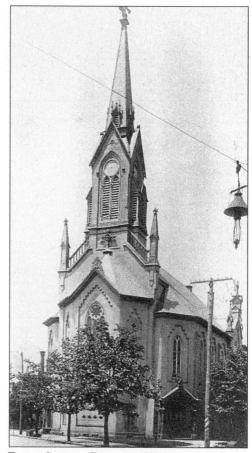

FIFTH STREET BAPTIST CHURCH, 1895.

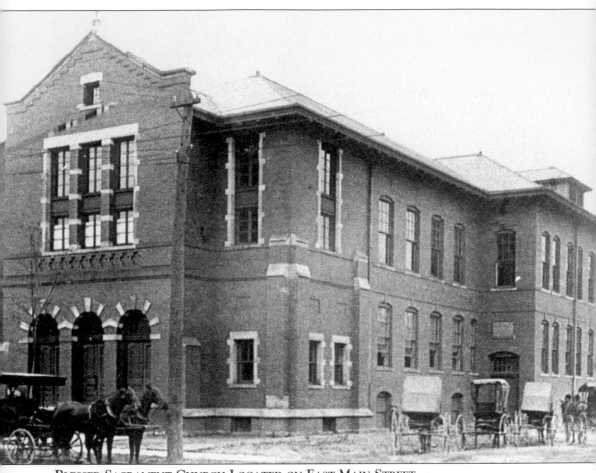

Blessed Sacrament Church Located on East Main Street.

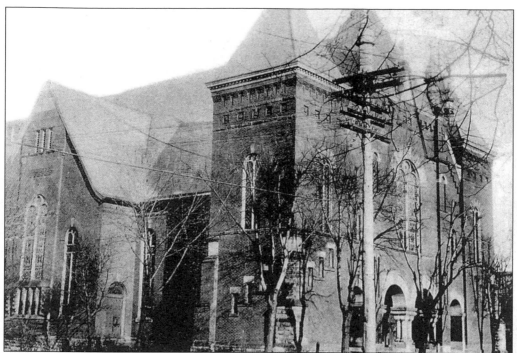

St. Francis de Sales' Church. St. Frances de Sales' was located on the north side of Granville Street between Fifth and Sixth Streets.

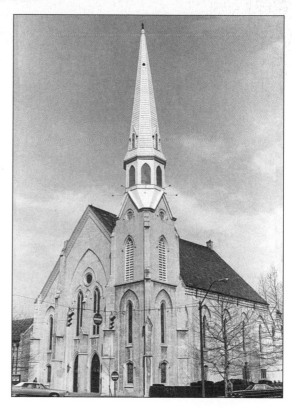

Second Presbyterian Church. Second Presbyterian was on the north side of Church Street between First and Second Streets.

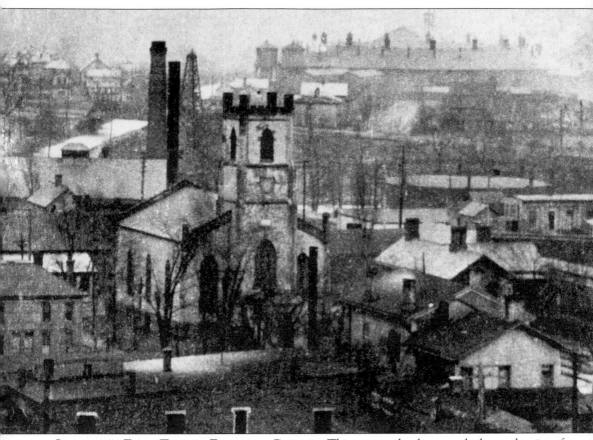

SITE OF THE FIRST TRINITY EPISCOPAL CHURCH. This very early photograph shows the site of the first Trinity Episcopal Church in Newark, organized by the Right Reverend Philander Chase, Bishop of Ohio, early in the year 1826. The church was on South First Street, between East Main and the canal.

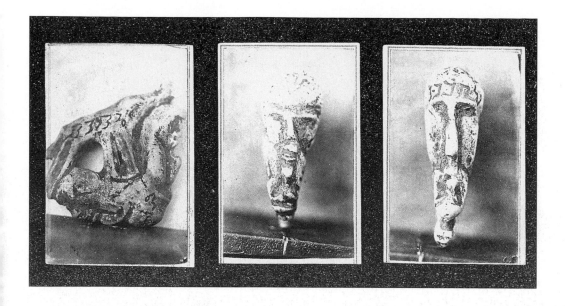

THE "HOLY STONES." These are early photographs of stone specimens believed to be the controversial Newark "Holy Stones." The stones, found near Newark by David Wyrick in the 1860s, are believed by some to be evidence that Hebrew seafarers came to America in ancient times. That theory has been disputed by modern scientists, who claim Wyrick forged the stones to further his personal beliefs. The bottom photograph shows the information recorded on the back of the photographs.

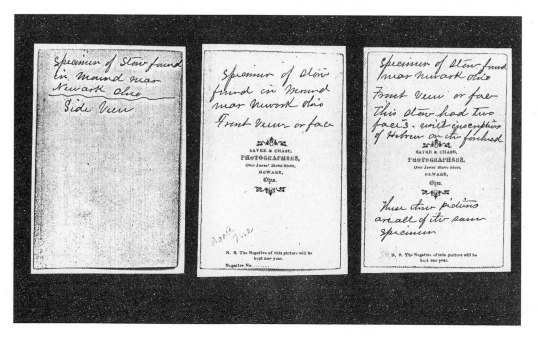

Schools in the Newark area *circa* 1900 included the following:

River Side School
Old West End School
New West End School
Hudson Avenue School
East Main Street School
Wood Side School
High School

Mill Street School
South Third Street School
North Fourth Street School
South Fifth Street School
Central School
Indiana Street School

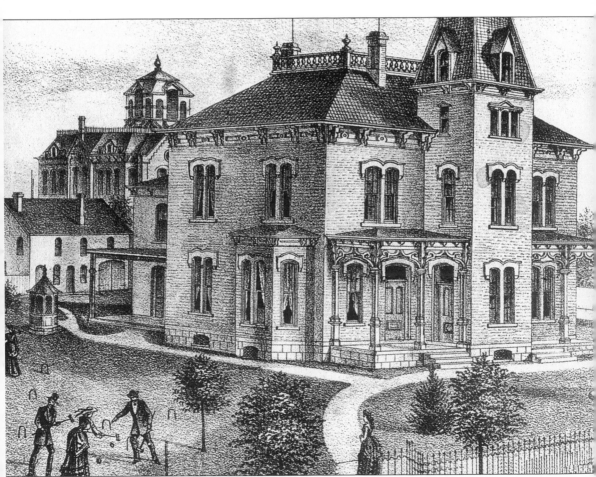

THE SCHOOL BELL TOWER. The North Fourth Street School bell tower can be seen in this sketch to the left in the background.

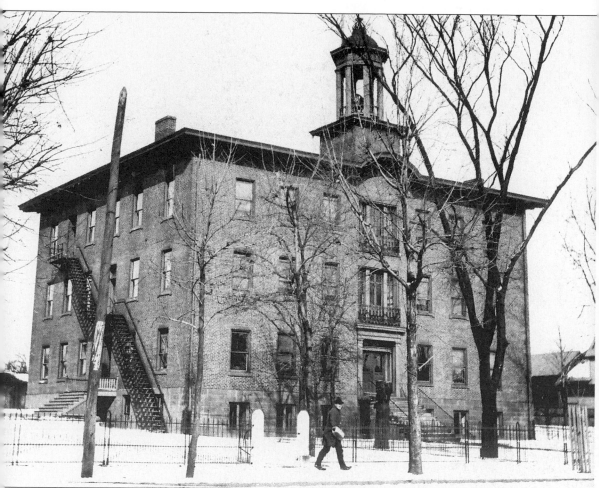

CENTRAL SCHOOL. On a wintry day a passerby walks in front of the old Central School, now known as Central Intermediate School, located on West Church Street.

NORTH THIRD STREET SCHOOL, 1897.

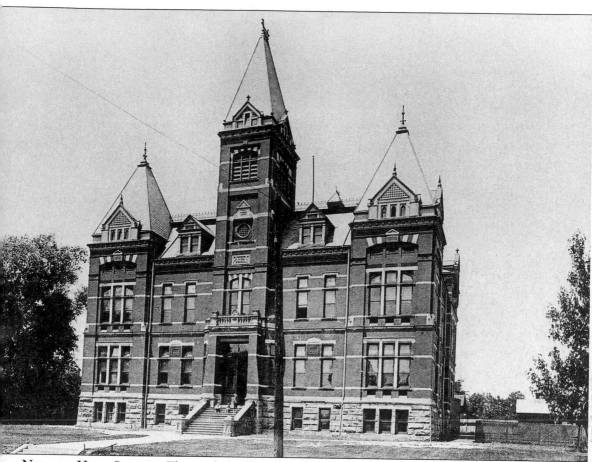

NEWARK HIGH SCHOOL. This is the old Newark High School, which was located on West Main Street near Fifth Street.

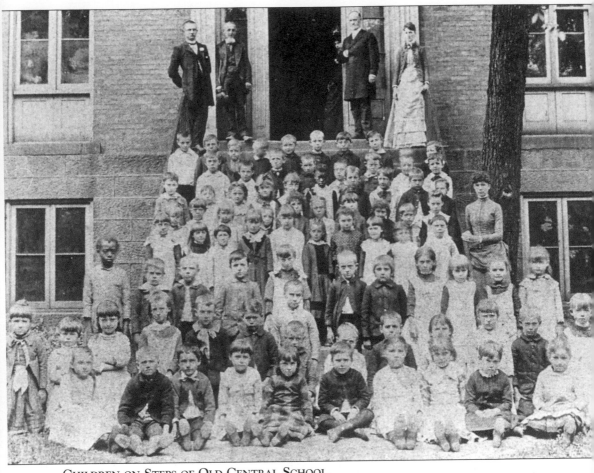

CHILDREN ON STEPS OF OLD CENTRAL SCHOOL.

Eight
RAILS, FIREMEN, POLICEMEN, AND PARADES

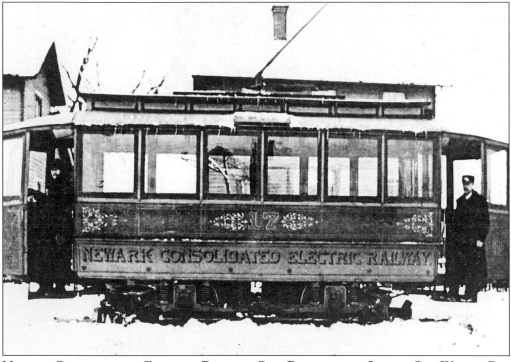

NEWARK CONSOLIDATED ELECTRIC RAILWAY CAR, BUILT BY THE JEWETT CAR WORKS. Few cities had the advantage of such railroad facilities as Newark. Trunk lines of the Pennsylvania and B&O Railroads crossed east and west, affording 12-hour service to New York, Philadelphia, Baltimore, and Washington, and 10-hour service to Chicago. In addition to steam railways, interurban electric railway service was available in Newark. The Ohio Electric Railway carried passengers from the east through Newark to Columbus, Dayton, and Springfield. Some 60 high-speed electric trains ran in three directions out of Newark daily. This electric service carried passengers, freight, and express. To the southwest, the Ohio electric ran to Buckeye Lake, one of the most attractive and popular summer resorts in the state.

Newark's first fire engine was purchased in 1859. It was delivered by train from Columbus, removed from the railroad car, and taken to the old Newark Machine Works for inspection. The fire engine was demonstrated at the northwest corner of the Square, where a cistern had been installed to use in fighting fires downtown. Similar cisterns were also in place at the other three corners of the Square. As part of the demonstration, firefighters pulled the heavy (5,300 pounds) pumper around the Square. The "fire ladies" (as they were known in those days) put cold water in the boiler, fired it up, and nine minutes later, it was steaming. They fired a stream of water over the top of a hotel (the Murray House), which had recently been constructed after a fire had destroyed the entire block. The cost of the pumper was $4,500, which was a substantial amount of money in 1859. Before the Square had been significantly developed, the city's canals were used to supply water for fighting fires. When buildings began to thickly line the Square, the cisterns were installed.

The Newark police force worked day and night. Patrolmen were on the alert for run-away teams, and for visitors who had imbibed too much. However, there were no traffic-rule violations to worry about. For winter duty, they were smartly dressed in double-breasted overcoats with braid fasteners and high collars.

Many parades were held in the early days. They were held on the occasions of just about any celebration and brought families from the county into the city for a day of fun and fellowship.

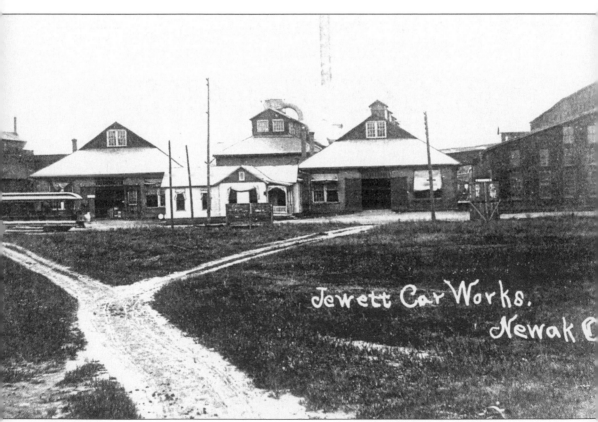

JEWETT CAR WORKS. The Jewett Car Works factory was located in Newark, Ohio.

Ohio Electric Ry.

"THE WAY TO GO"

THE

ONLY

DIRECT

ROUTE

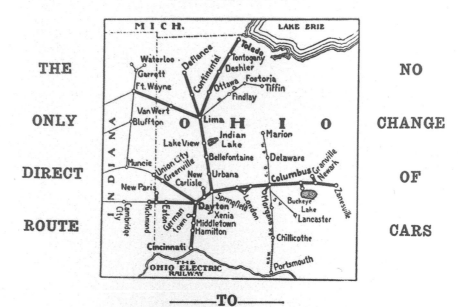

NO

CHANGE

OF

CARS

——— TO ———

BUCKEYE LAKE

Hourly Service From

Columbus—Newark—Zanesville

And All Intermediate Points.

Direct Connections at Columbus From
**Springfield, Dayton, Richmond, Indianapolis, Lima, Ft. Wayne
and Toledo.**

PARTY AND CHARTERED CAR RATES FURNISHED ON APPLICATION.

See nearest agent, or address

B. B. BELL, D. P. F. A. W. S. WHITNEY, G. P. F. A.,

ADVERTISEMENT FOR THE OHIO ELECTRIC RAILWAY. Electric Railway service ran hourly to Buckeye Lake from Columbus, Newark, and Zanesville. The author rode these cars to school in first and second grade.

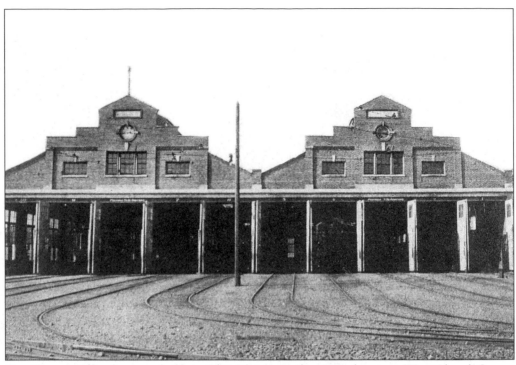

CAR BARNS. This photograph shows Ohio Electric Railway's car barns on West Church Street.

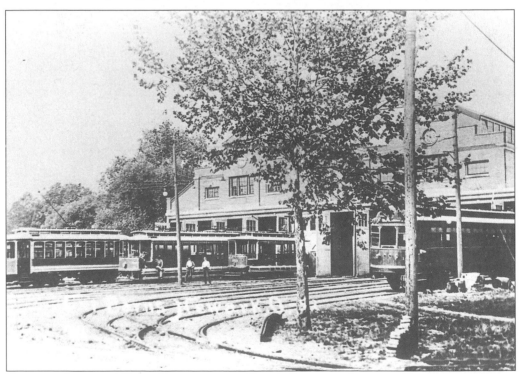

TROLLEY GARAGE. The trolley garage on Church Street was later used by the Ohio Power Company.

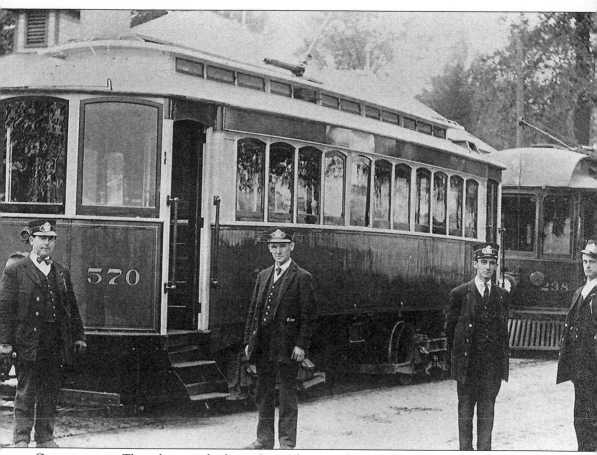

CONDUCTORS. This photograph shows Interurban conductors. Scott Orr is the conductor second from the left.

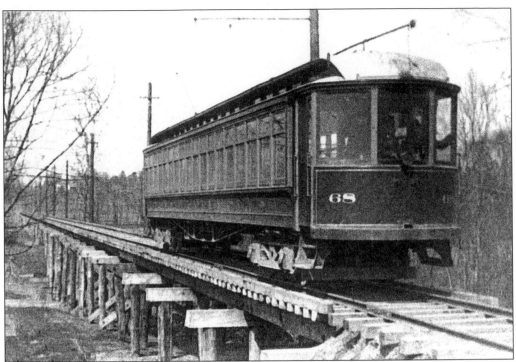

INTERURBAN CAR. One of the Interurban railroad cars sits at the Pine Street trestle.

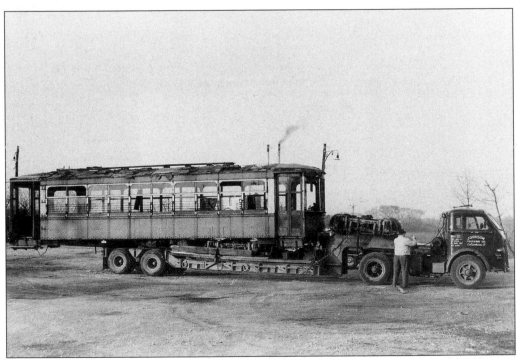

THE GLORY YEARS AT AN END. The old Interurban railroad cars that served Licking County were stripped of their steel wheels, which were replaced with rubber tires to permit the cars to be towed to a local scrap yard.

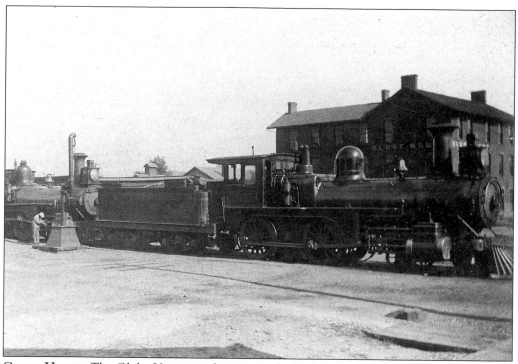

GLOBE HOUSE. The Globe House can be seen in the background.

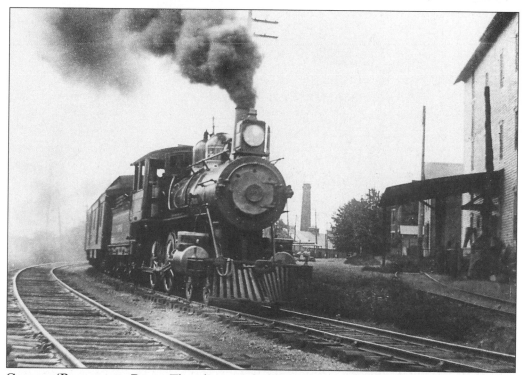

COMING 'ROUND THE BEND. This photograph shows a train coming around the curve on East Main Street.

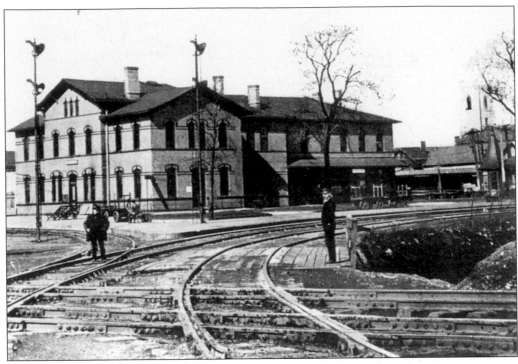

BALTIMORE & OHIO RAILWAY STATION.

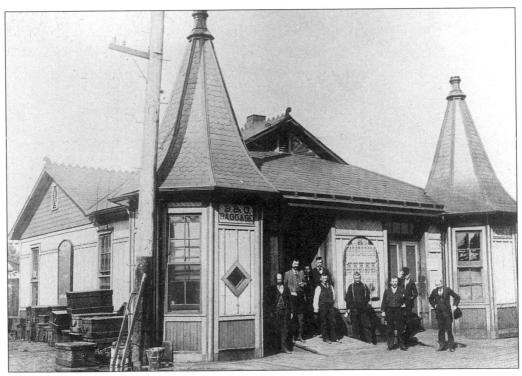

BALTIMORE & OHIO BAGGAGE STATION.

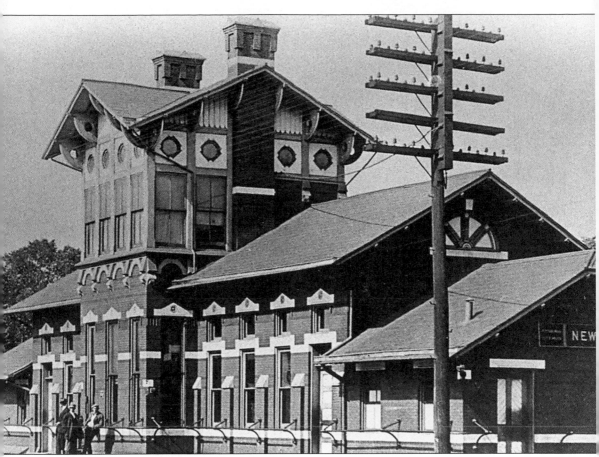

Pennsylvania Railway Station.

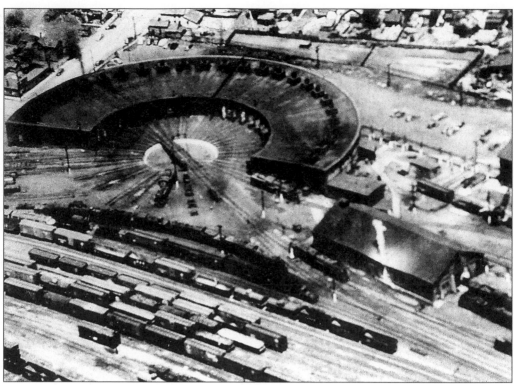

EAST END TRAIN YARDS. This photograph shows an aerial view of the old East End train yards.

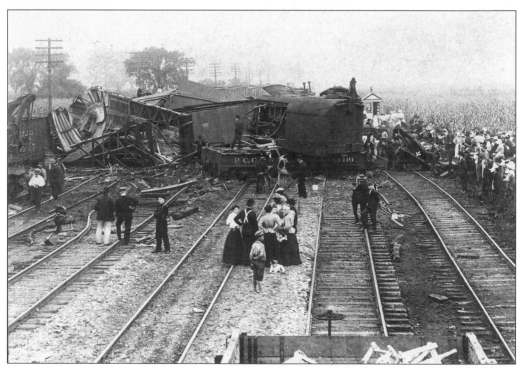

TRAIN WRECK. This is a photograph of the terrible train wreck of August, 1907.

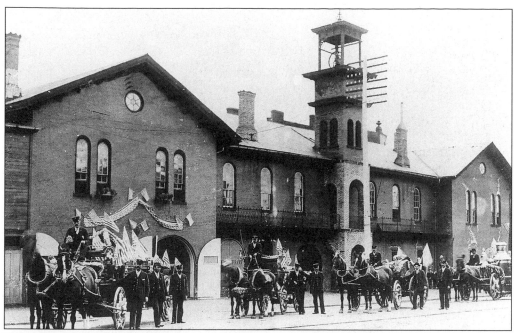

First Fire Truck. Newark purchased its first fire truck around 1859. The Silsby fire engine was a steamer that was pulled by two horses. Steam pressure was used to pump water through the fire hose. The location of this photograph is Fourth and Main Streets.

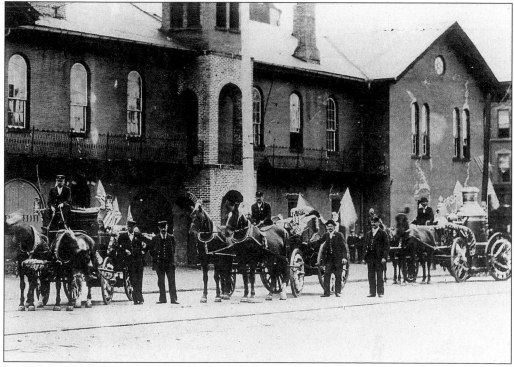

Fire Fighters. These early Newark fire fighters are all decked out for a parade. Their pumper truck was decorated for the occasion, probably the Fourth of July.

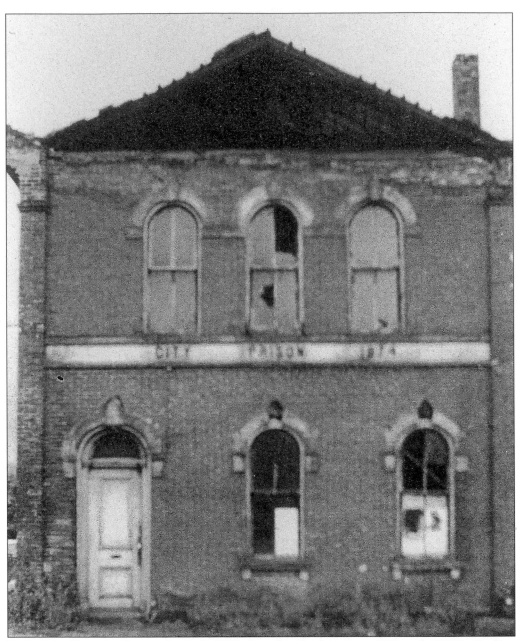

THE CITY PRISON. It wasn't until 1835 that the third mayor of Newark, M.M. Carffee, appointed the first law-enforcement officer. His name was Marshal P. Morrison. During the early days of Newark, the principal duties of the marshal were to keep noise down and to prevent animals and intoxicated persons from running amok in the village. The city prison was built of brick in 1874 on the canal feeder, just south of East Main Street at the B&O crossing. The prison was called many names, such as: "Lockup," "Hoosegow," "JailHouse," "Clink," "Hobo's Rest," "Hotel de Hobo," and "Little Brown Jug." When drunks on the Square could not navigate down to the Little Brown Jug, the constable would dump the inebriated into a wheelbarrow and push it down Main Street to the jail. The wheelbarrow was kept parked on Gingerbread Row for quick trips to the jail.

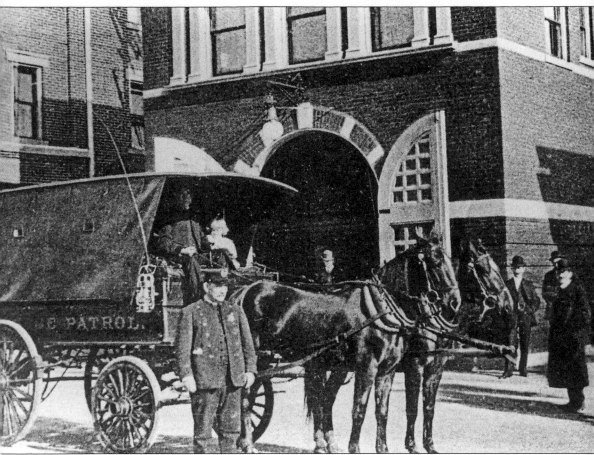

FIRST POLICE PATROL WAGON. Newark put its first police patrol wagon into service in 1906. Before this, officers who made arrests walked their prisoners to the city jail on East Main Street at the railroad, or hauled them in wheelbarrows or by horse drawn cab. The new patrol wagon was equipped with stretchers and rubber tires. It was pulled by beautifully matched black horses.

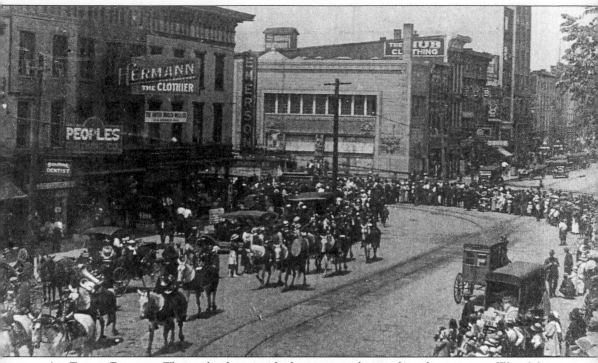

An Early Parade. This early photograph shows a parade rounding the corner at West Main and Third Street. Notice the Sullivan Building in the background.

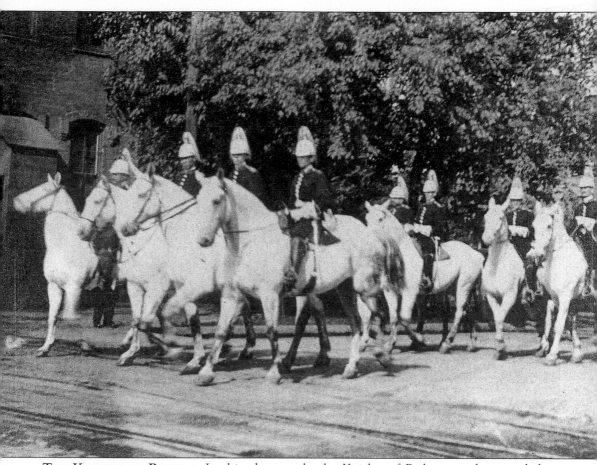

THE KNIGHTS OF PYTHIAS. In this photograph, the Knights of Pythias parade around the Courthouse Square *circa* 1915. (Photograph by Chalmers Pancoast.)

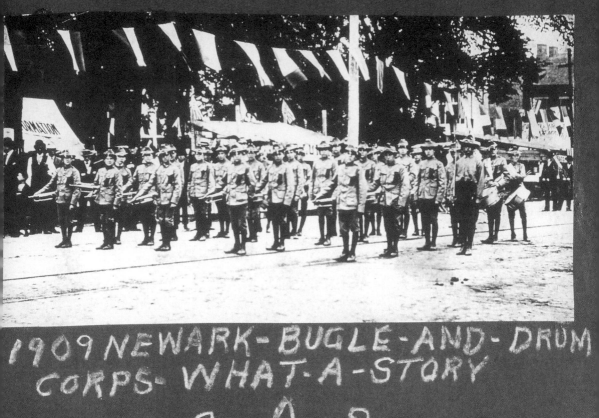

NEWARK BUGLE AND DRUM CORPS, 1909. (PHOTOGRAPH BY CHALMERS PANCOAST.)

Nine

HOUSES, INDUSTRIES, STREET SCENES, AND PEOPLE

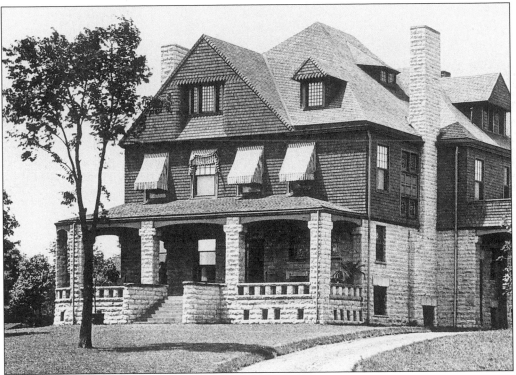

THE HENRY S. FLEEK RESIDENCE AT 431 HUDSON AVENUE C. 1895. Many architecturally rich residences were built around the city as business and industry brought prosperity to the citizens of Newark. Within a few years the city traded the canal boat for the trolley and steam express; the stage coach for the parlor car, automobile and aeroplane; coal, oil, and gas street lamps for electric light, Tungsten lamps, and Newark-made Holophane reflectors; and the no-stove foundry for the Wehrle works—the largest in the world, covering 20 acres under roof. The city also claimed to have both the largest halter factory and the largest bottle factory in the world. Newark-made electric cars were running in every important city; the Heisey "Diamond

H" table glassware and the Holophane reflectors were known the world over. Modern factories and modern methods brought many people to the city of Newark. Some of the factories included the Newark Gearwood Company, the Smith Shoe Company, the Blair Manufacturing Company, the Newark Furniture Company, the Scheidler Machine Company, the Wyeth Company, the Consumers Company, the Buckeye Rail Company, the Swisher Bros.' Cigar Factory, and the Vogelmeier Brick Yards. W.S. Weiant & Son had the largest greenhouse in Ohio, with five acres under a glass roof where winter vegetables were grown and shipped into three states.

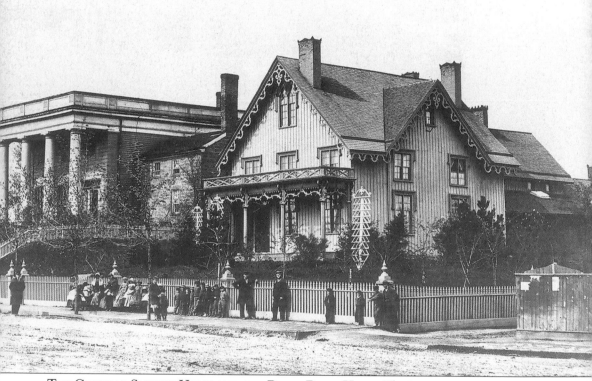

THE GENERAL SMYTHE HOME AND THE PERRY RANK HOME. The imposing stone structure on the left was known as the General Smythe Home. It was an outstanding landmark, standing there for many years, proudly displaying architecture unequaled in Newark for dignity and stateliness. The solid stone masonry, with four large columns or pillars, could have been copied from the Greek or Romans. This stately mansion stood upon a high terrace, supported by a stone wall, running the entire length of Church Street and fronting on Fourth Street. General Smythe resided in Newark from 1834 until his death at the age of 92 in 1898. The home on the right is that of Perry Rank, the livery-stable proprietor. This structure, a frame building, exhibits a style known as "Carpenter's Gothic." Note the lace-work trimming on both cornice and porch. The Perry Rank livery stable was to the south across the alley.

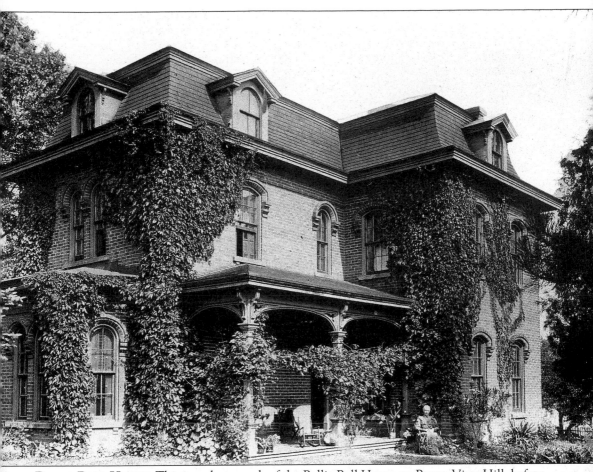

BALLIE BALL HOUSE. This is a photograph of the Ballie Ball House on Buena Vista Hill, before the devastating fire.

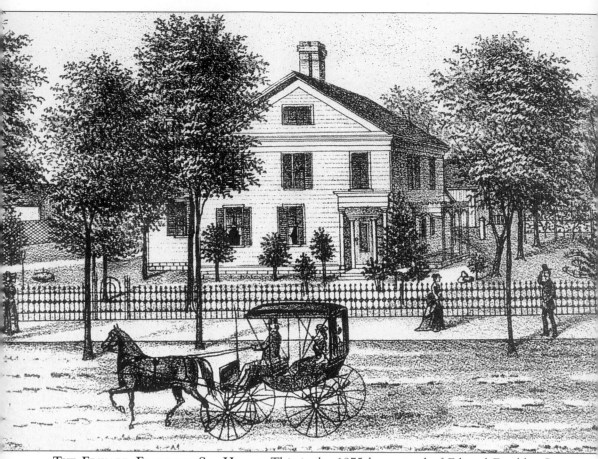

THE EDWARD FRANKLIN SR. HOUSE. This is the 1875 homestead of Edward Franklin Sr., which was located at 50 Hudson Avenue.

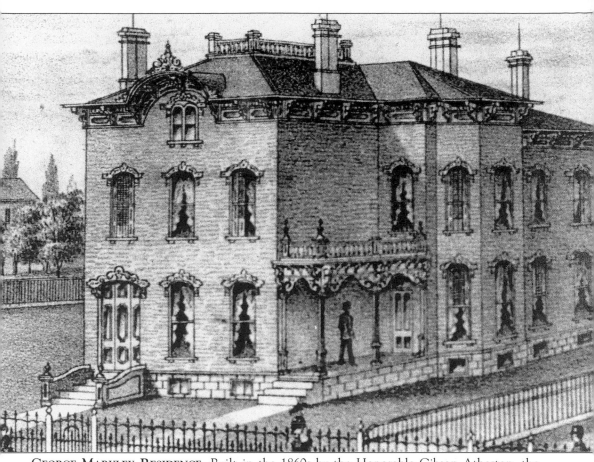

GEORGE MARKLEY RESIDENCE. Built in the 1860s by the Honorable Gibson Atherton, the George Markley residence, located on Hudson Avenue, is shown here in 1875.

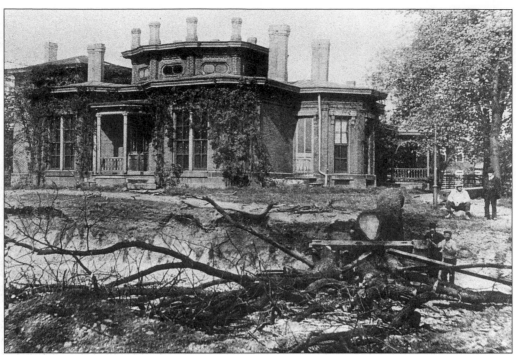

THE EDWARD H. EVERETT HOME. The Edward H. Everett home was located on Buena Vista Street.

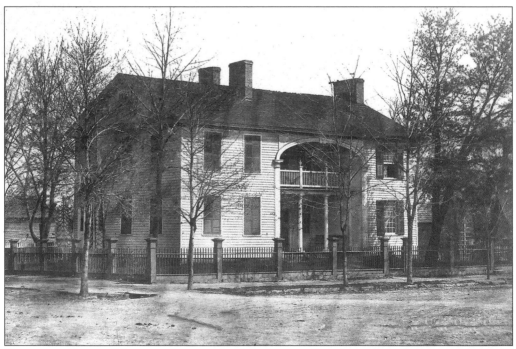

DAVIDSON HOUSE. This is a photograph of the historic Davidson House before it was moved and reconditioned.

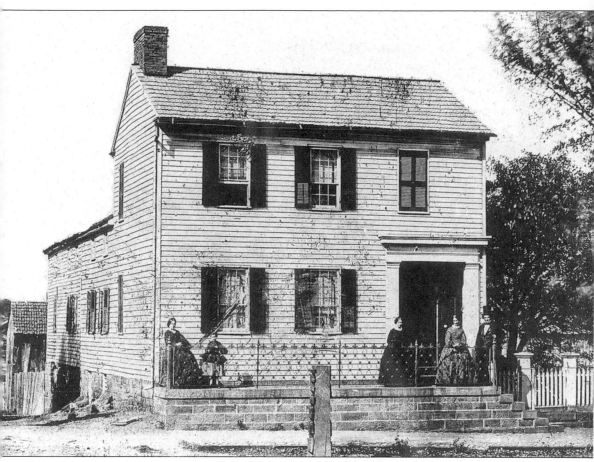

JOHN MOONEY AND DAUGHTERS. John Mooney and his daughters pose for a photograph on their front porch.

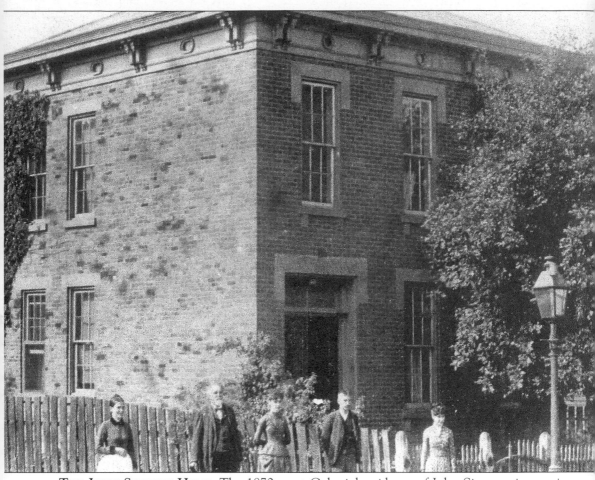

THE JOHN SIMPSON HOME. The 1870s post-Colonial residence of John Simpson is seen in this photograph.

OLD HOUSE ON THE MIDLAND THEATER SITE. This is the house that stood where the Midland Theater stands today in downtown Newark, at the corner of North Second Street and North Park Place.

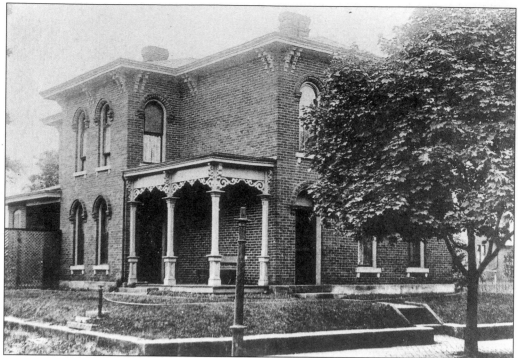

THE J.A. FLORY HOME. This was the J.A. Flory family's brick home at 259 West Locust in Newark. It was built to last, as most homes in the 1800s were.

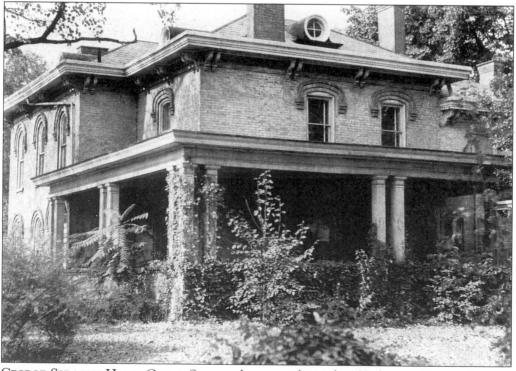

GEORGE SPRAGUE HOME. George Spragues home was located on Hudson and Locust Streets.

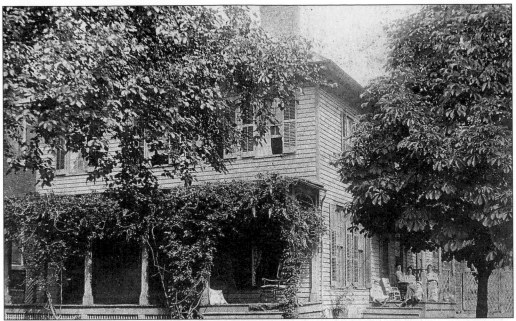

TIEMANN HOME. This was the home of the Honorable and Mrs. W.F. Tiemann. It was on West Main Street on the site of the old Newark High School.

KING RESIDENCE. The King home was located on North Second Street.

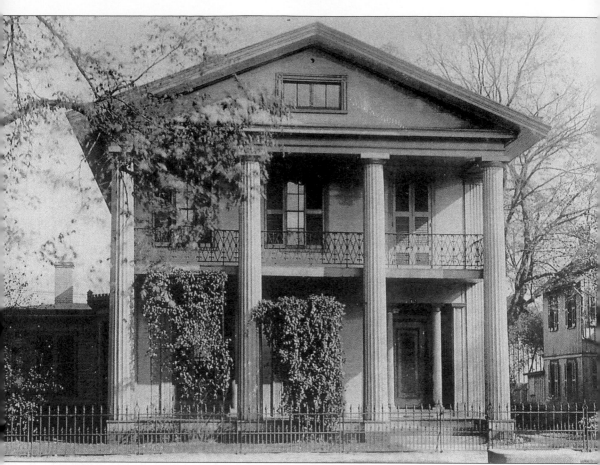

THE BUCKINGHAM HOUSE. The Buckingham House, built in 1835, was the home of Judge and Mrs. Jerome Buckingham. Over time, the house was witness to many parties with distinguished visitors such as Presidents Rutherford B. Hayes and James A. Garfield. Many senators, statesmen, and other notables of the Civil War era, including General Sherman and General Sheridan were guests in the home.

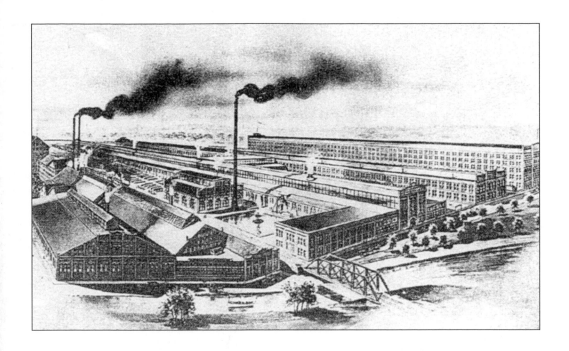

THE WEHRLE COMPANY. The largest stove foundry in the world, the Wehrle Company, was located in Newark, Ohio. The mammoth plant had the ability to manufacture 900 stoves a day. The roofs of its buildings covered over 20 acres. Besides making a great variety of stoves and ranges, the Wehrle Company manufactured office safes and a great variety of kitchen utensils. Early catalog drawings of Wehrle stoves are seen below.

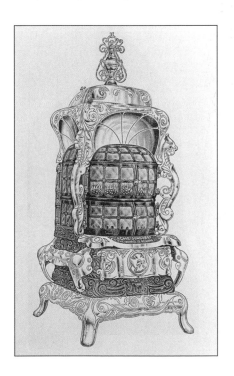

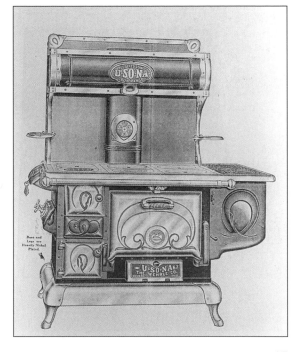

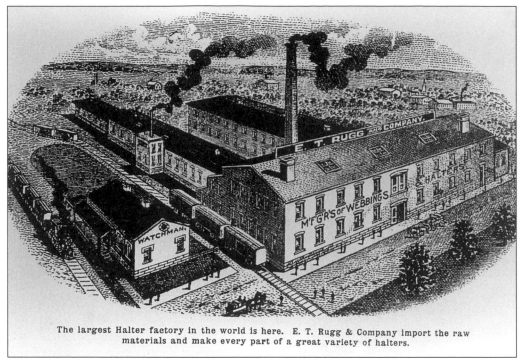

The largest Halter factory in the world is here. E. T. Rugg & Company import the raw materials and make every part of a great variety of halters.

E.T. RUGG & COMPANY. The largest halter factory in the world was located in Newark, Ohio. The E.T. Rugg & Company imported the raw material and made every part of a great variety of halters.

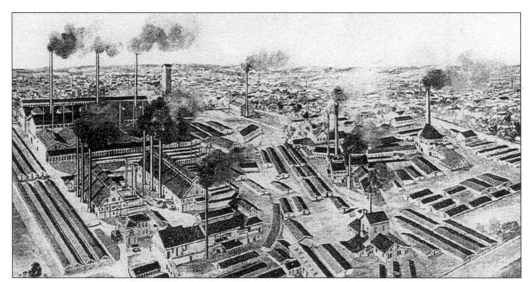

THE AMERICAN BOTTLE PLANT. This sketch gives a bird's eye view of the American Bottle Plant that was located in Newark, Ohio. Besides operating 27 Owens Bottle Machines, each capable of producing 14 bottles a minute, 23 hours out of every 24, the company also produced high-grade glassware.

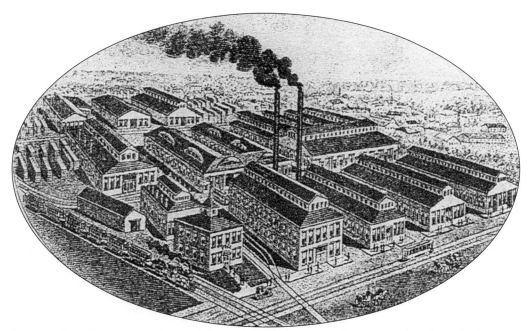

JEWETT CAR COMPANY'S PLANT. The Jewett Car Company factory employed nearly 500 men in the manufacturing of streetcars. Newark-made streetcars were seen in every important city in the United States.

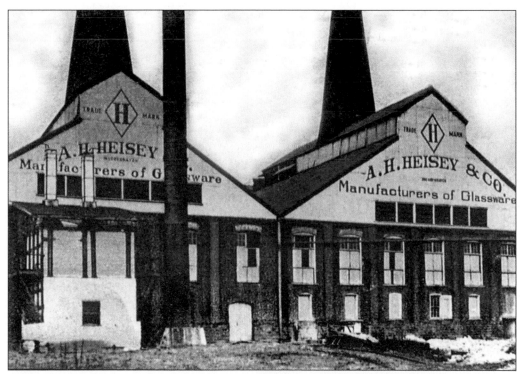

A.H. HEISEY & COMPANY'S TABLEGLASS FACTORY. A.H. Heisey & Company produced "Diamond H" Glassware, which is known all over the world.

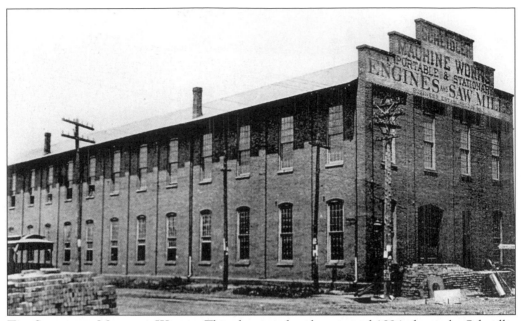

THE SCHEIDLER MACHINE WORKS. This photograph, taken around 1894, shows the Scheidler Machine Works building. The building was formerly Consolidated Electrical Distribution. The building was purchased by Howard LeFevre, who turned the structure into a museum of local business and industry now known as The Works. Below, on the right, is an advertisement for Scheidler Machine Works. On the left is an enlargement of Scheidler Machine Works facing First Street.

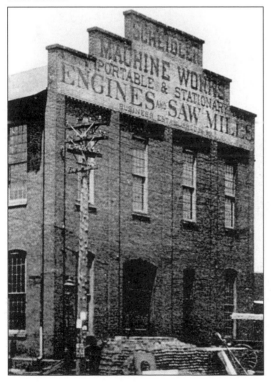

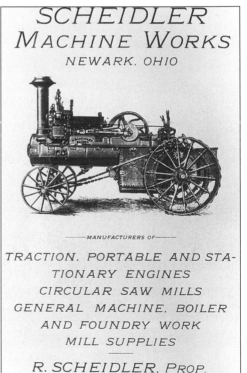

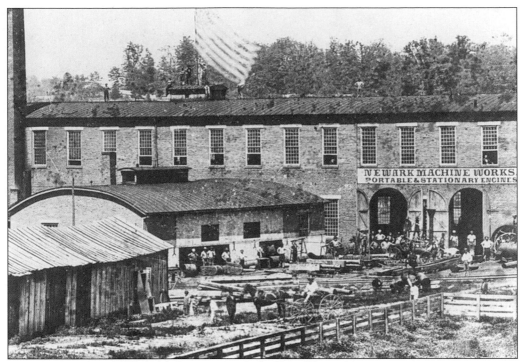

NEWARK MACHINE WORKS. The Newark Machine Works was located on the southeast corner of Locust and North First Streets.

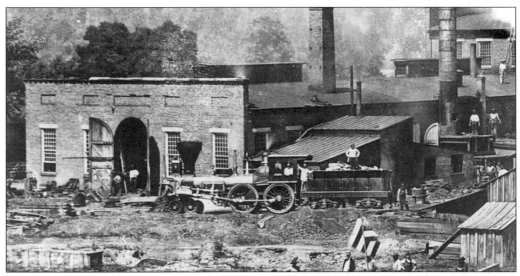

ON THE GROUNDS OF THE NEWARK MACHINE WORKS. This locomotive on the Newark Machine Works grounds dates the photograph back to 1865.

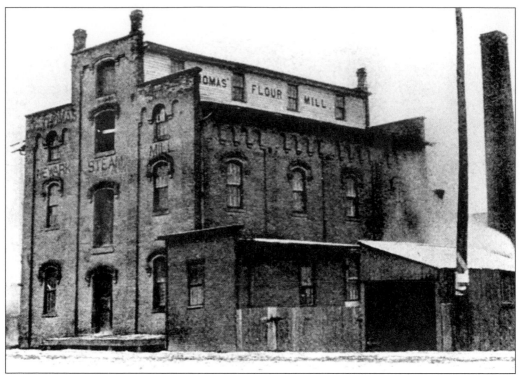

D. Thomas & Son Flour Mill. The D. Thomas & Son Flour Mill was located on the canal at Second Street.

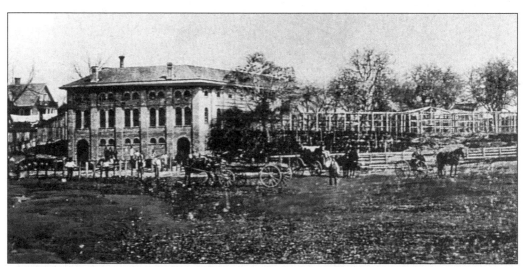

Morath Brewery. The old Morath Brewery and gardens stood on Church Street, between Sixth and Eighth Streets. The dwelling to the right is the old home of Michael Morath. The brewery and the Morath residence were connected by a long arbor which had a fountain in the center. In the summertime "thirsty folks" occupied tables and chairs placed under the arbor. In the foreground may be seen the wagons which came in from nearby towns to haul the brew away.

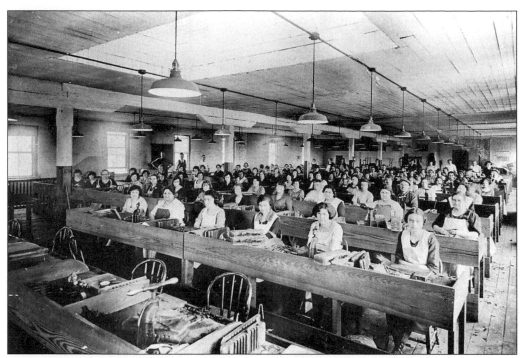

NEWARK CIGAR FACTORY. This photograph shows workers in the Newark Cigar Factory.

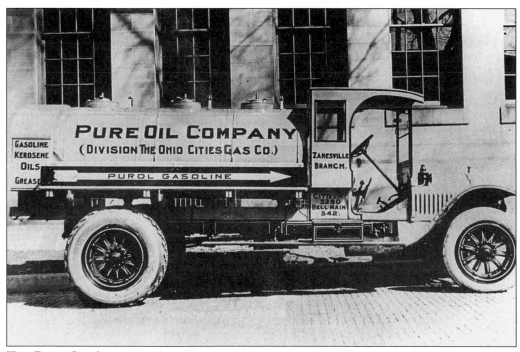

THE PURE OIL COMPANY.

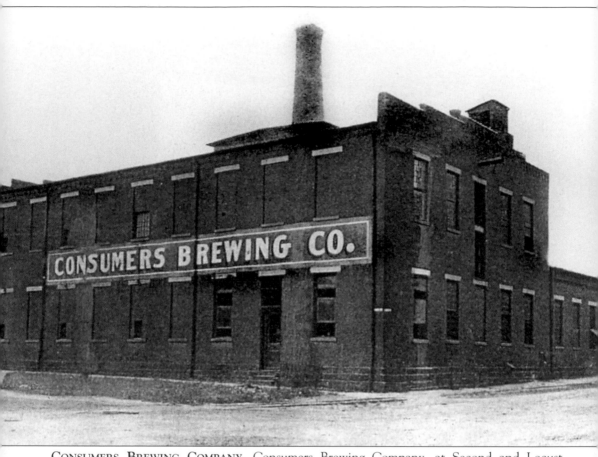

CONSUMERS BREWING COMPANY. Consumers Brewing Company, at Second and Locust Streets, was a modern institution with its own ice-manufacturing department.

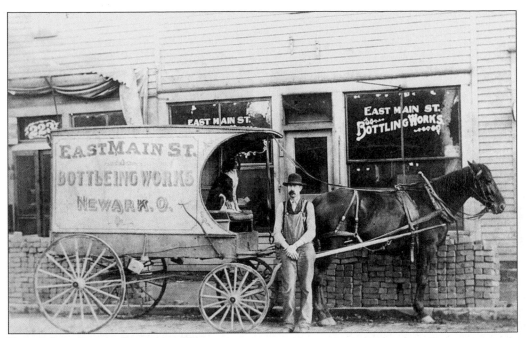

EAST MAIN STREET BOTTLING WORKS.

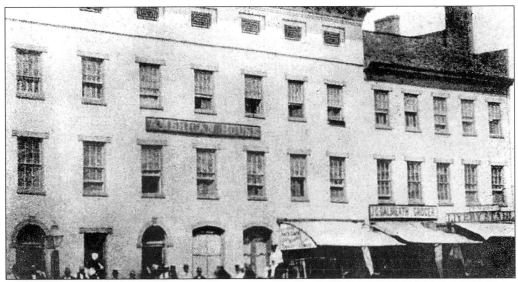

AMERICAN HOUSE HOTEL. This is a very early photograph of the American House Hotel.

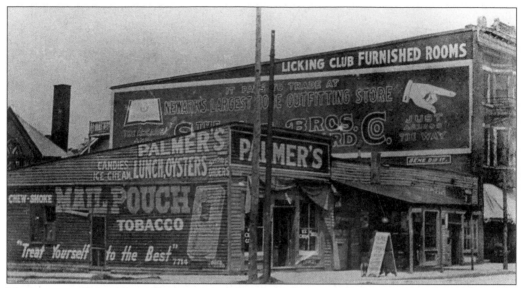

NORTHEAST CORNER OF FOURTH AND CHURCH STREETS. Prior to 1912, this is how the northeast corner of Fourth and Church Streets appeared. Central Church of Christ is at the extreme left; Palmer's luncheon facility is on the left. To the right is the Donovan Building, which then housed Litchenstein's Grocery. Note the sign on the building points to the Stewart Brothers and Alward Store across the street. The building at the extreme right housed a Chinese laundry. In 1913 the Masonic Temple was built on the northeast corner of Fourth and Church Streets.

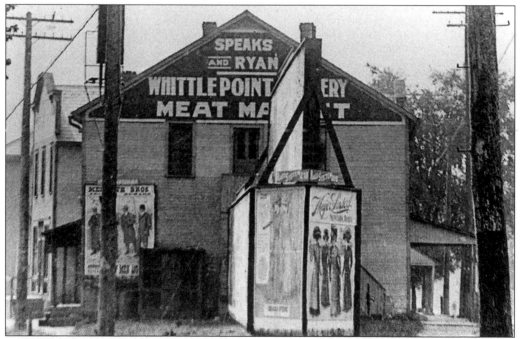

"THE POINT." For motorists, this is a familiar area along Mount Vernon Road. It is what some people call "the Point" or "Triangle Point." In 1909 it was called "Whittle Point," for Whittle Point Meat Market.

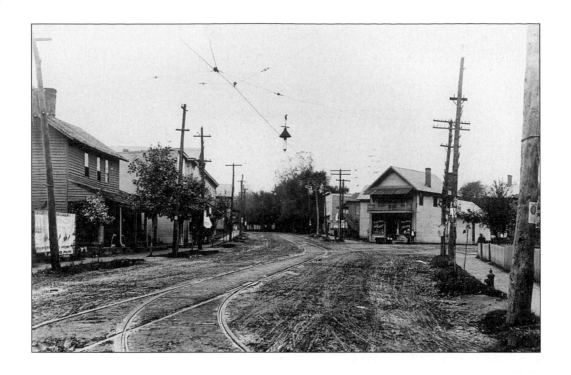

"**Buehler's Corner.**" This old photograph shows "Buehler's Corner," owned by Tinnel Buehler. It was a familiar landmark at the "V" junction of West Main Street and Eleventh Street. This photograph reveals a muddy, rutted road, new trolley car tracks, and an overhead carbon arc-street-light. Below is another view of the corner of West Main Street and Eleventh Street.

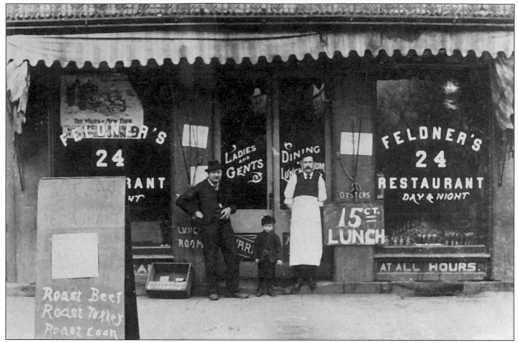

FELDNER'S RESTAURANT. Feldner's Restaurant was famous in the early part of the century for its 15¢ lunch. On this particular day back in 1910, the restaurant featured roast beef, roast turkey, and roast coon, according to the lunch board on the left. The eatery was located on the north side of the Square in downtown Newark.

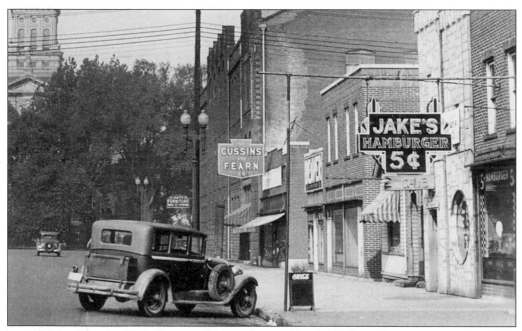

EAST MAIN STREET. This photograph was taken on East Main Street looking west, *circa* 1933. The old Cussins and Fearn store and Jake's Restaurant, famous for its 5¢ hamburgers, are on the right. Up the street, beyond Cussins and Fearn, is the sign pointing to the Scott Furniture Store.

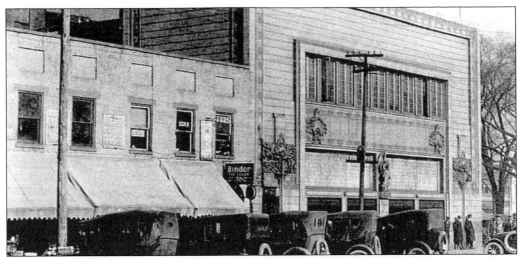

THE SULLIVAN BUILDING. One of America's most famous architects, Louis Sullivan, changed the look of Newark's Courthouse Square when he designed the Old Home Bank in 1914. According to Marilyn Hirshler of the *Newark Advocate*: "The Old Home Bank on the northwest corner of the Square is one of a series of small midwestern banks designed by Sullivan toward the end of his career. Sullivan's style can be best described as practical, but he insisted that beauty always be an element of the design. Geometric in shape, the sharply rectangular lines of the building are softened by the decorative façade. Bouquets of foliage bristle and seem to spring up from the ground on long columnar stems. Above, blue, green, and gold mosaics add color to the façade. Much of Sullivan's inspiration came from the home he maintained in Ocean Springs, Mississippi, with its intricate gardens and myriad varieties of roses and other plants. The Newark building shows in detail his desire to marry the beauties of nature to the geometric forms of architecture to produce a style that had not been seen before in America."

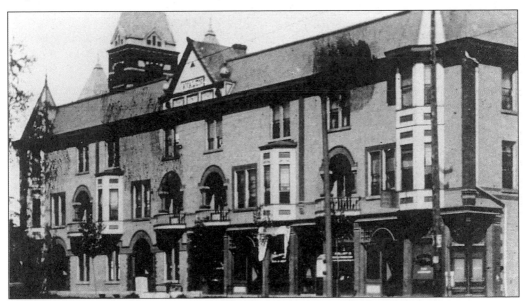

AVALON BUILDING. The Avalon Building, with its quaint architecture, stands proudly at West Main and Fifth Streets. The spire of the old Newark High School building towers in the background.

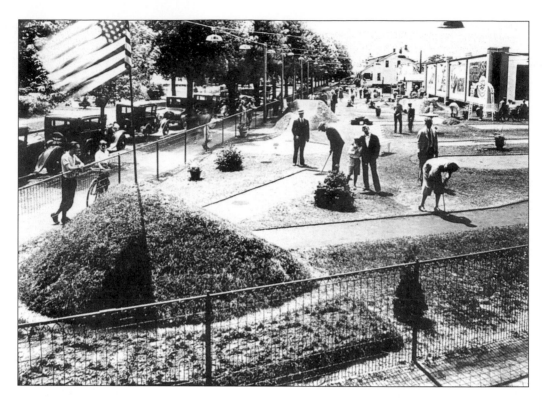

PUTT-PUTT. A pleasant Sunday afternoon in the early 1930s was spent by these ladies and gentlemen as they hit the golf ball around a putt-putt course that was located in the vicinity of current location of the Central Christian Church. Below, Roosevelt School is shown in the distant background and Mt. Vernon Road is to the right.

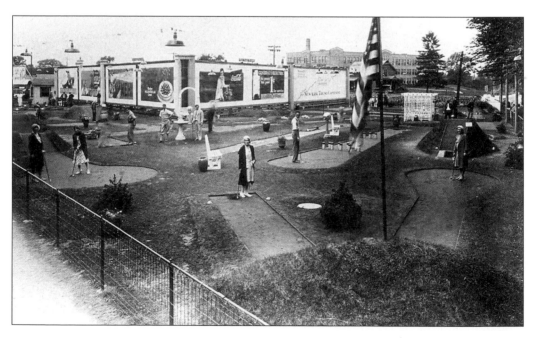

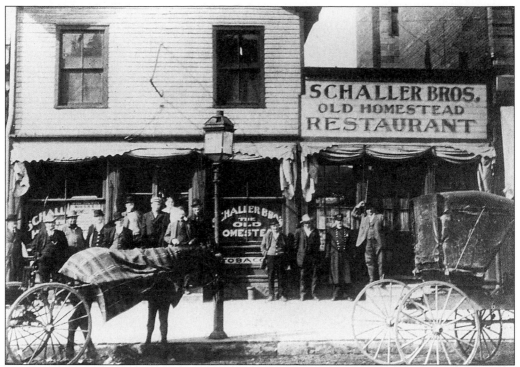

OLD HOMESTEAD RESTAURANT. This early photograph shows the Schaller Bros. Old Homestead Restaurant.

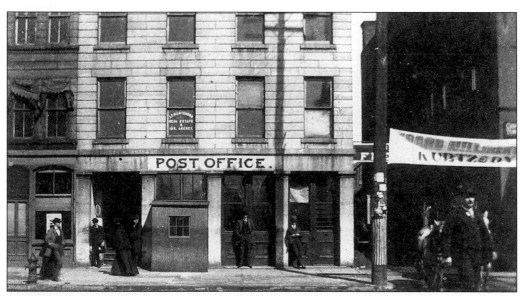

POST OFFICE BUILDING.

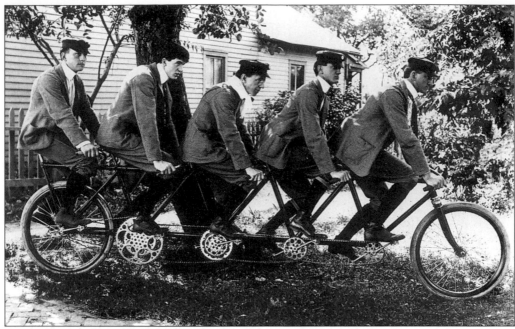

THE QUINTETTE CYCLE. This "Quintette" cycle, the only one in Newark, was ridden by these young men to Buffalo, New York in 1901, for the Pan-American Exposition. From left they are: Huett (Buz) Shauck, Walter Daughterty, James T. Haynes Sr., Joe Schlegel, and George T. Streams.

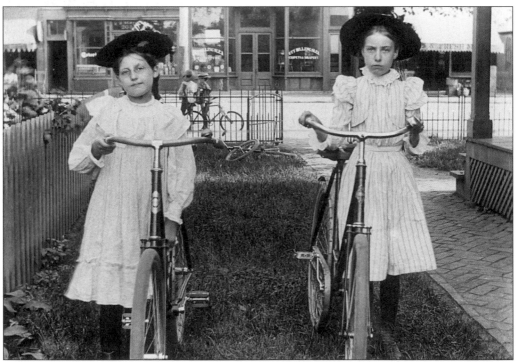

GIRLS WITH THEIR BIKES. Francis and Glenna (last name unknown) pose with their bicycles on East Main Street.

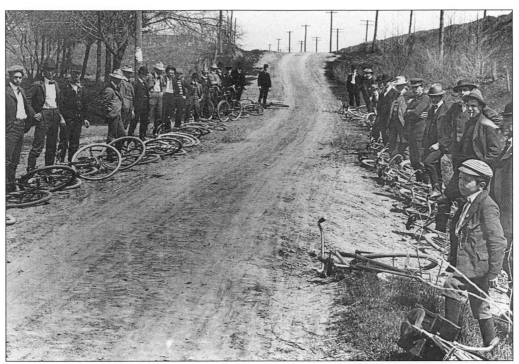

NEWARK BICYCLE CLUB. The Newark Bicycle Club lines the road to Vanatta.

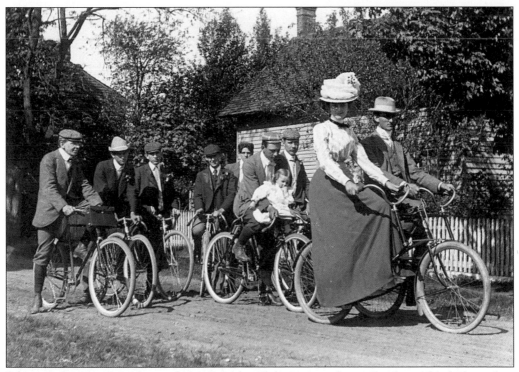

BICYCLE RIDERS. Members of the Bicycle Club are out for a Sunday ride. (Glass plate photograph by J.T. Haynes.)

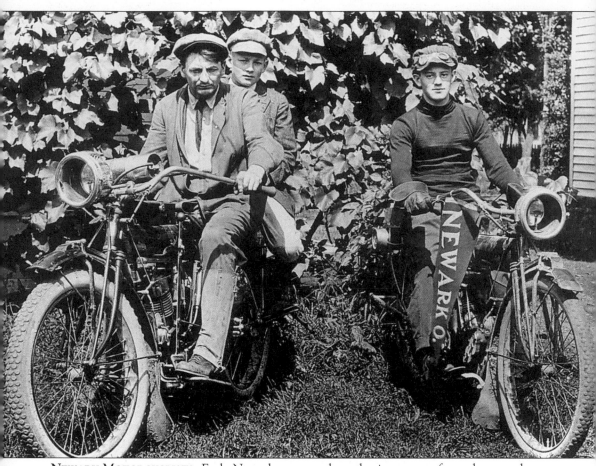

NEWARK MOTORCYCLISTS. Early Newark motorcycle enthusiasts pause for a photograph.

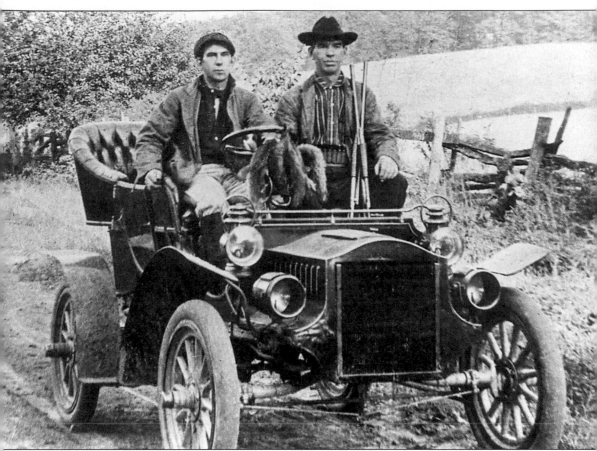

SQUIRREL HUNTERS DRIVING A SINGLE-CYLINDER CADILLAC AUTOMOBILE. Many years ago, in the 1800s, the law provided that every male person of military age was required to kill at least 100 squirrels per year and to deliver the scalps to their township clerk. Any man who delivered less than that number was compelled to pay 3¢ for each deficiency. If he accounted for 100, he was given credit for $3 on his tax bill. If he accounted for more than 100 scalps in any year, he was given a receipt, and the excess was credited on his next year's tax bill.

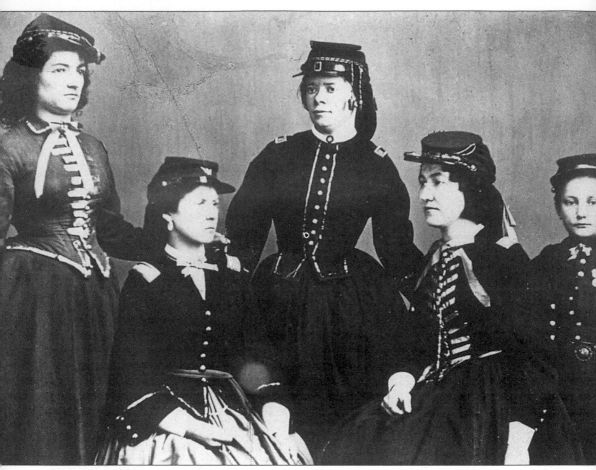

Civil War Women and Johnny Clem. Four Newark women accomplished something the Confederates struggled to do during the Civil War—capture Newark's Johnny Clem, who is better known as the legendary Drummer Boy of Shiloh. Clem is Newark's best-known contribution to the "War Between the States." Of course, the four women who posed with Clem in this old photograph did not actually "capture" Clem, but they persuaded him to join them in the formal photograph. From left to right are Helen King Spanger, Libbie Sparague Hamilton, Mary Warner Wilson, Mary (Mame) Ocheltree Kennedy, and Johnny Clem. According to accounts written in 1915, in the early 1860s an organization of women from the Newark area existed, who assisted sick and wounded Civil War soldiers from Licking County by sending provisions and clothing to the hospitals where the soldier were confined. The women dressed in a uniform that consisted of a military blouse or waist with military trimmings and epaulettes, and a soldiers cap, which gave them a definite military appearance. Clem was home on a furlough when he was persuaded by these four girls to accompany them to the Z.P. McMillen photography studio to pose for the photograph. Clem, who was also known as the Drummer Boy of Chickamauga, was reputedly the nation's youngest and smallest soldier in the regular army. He joined the Union Army at the unlikely age of 12.

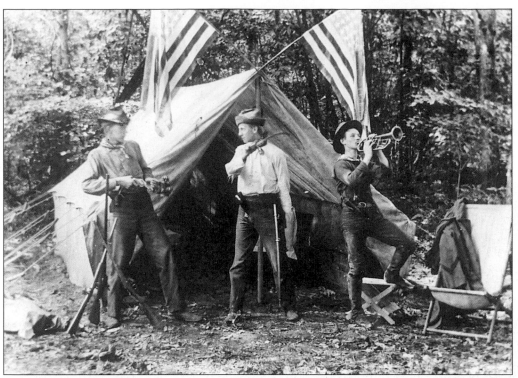

CAMPING IN THE 1890s. This photograph shows young men with patriotic flare in various uniforms camping in the 1890s, performing a morning bugle-led flag-raising, complete with "shotgun salutes."

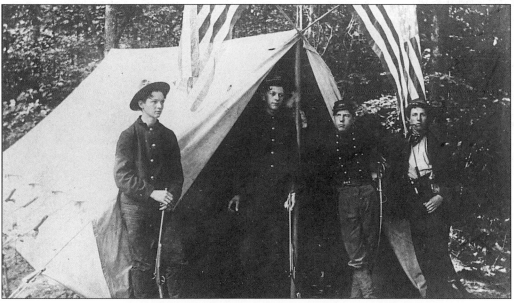

NEWARK HIGH SCHOOL CADETS. Pictured left to right are Chalmers Pancoast, Bun Woolway, Rob Hunter, and Pap Hart in the color guard uniform of the Newark High School Cadets, *circa* 1897.

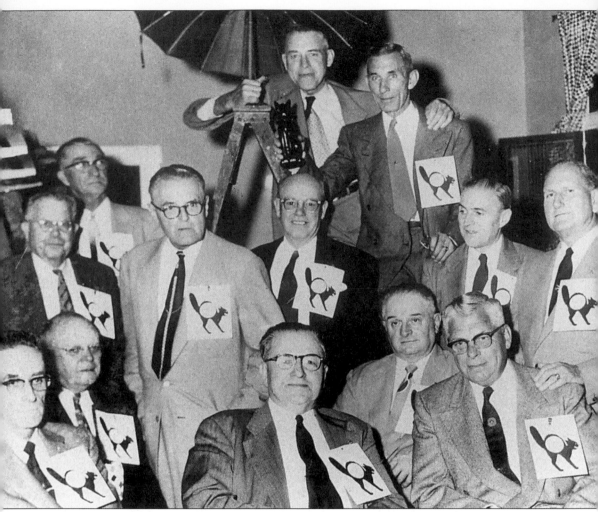

BLACK KATS. The Black Kats gathered at the old Carousel Supper Club on May 13, 1955, and formed the Last Man's Club as a friendly competition to see which would outlive all the others. The winner was J. Levi Phillips (standing under the umbrella). Others in the photograph include (front row, left to right) William Evers, John Sachs, and A.M. Brown; (second row, seated, left to right) John Duncan, who founded the Black Kats in 1941, and Andrew Jeffers; and (third row, left to right) an unidentified man, Ralph Grubaugh, Dr. Stewart Sedgwick, an unidentified man, Harry Rossell, and Ross Henderson. Standing to the right of Levi Phillips is Harold Wilson.

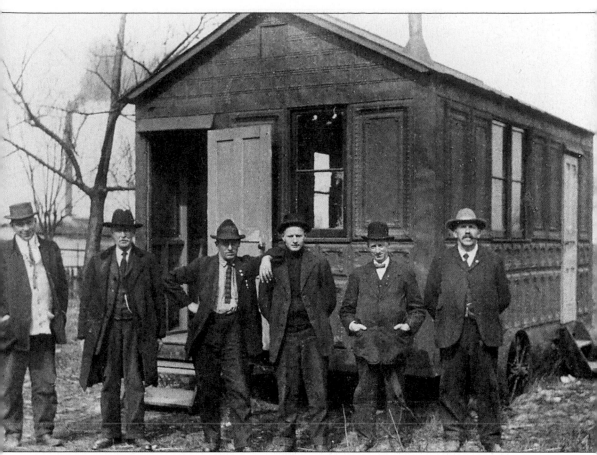

PORTABLE ELECTION HOUSES. Back when Woodrow Wilson was elected president, Licking County voters used portable election houses such as the one pictured here to cast their ballots. The houses were towed to precinct polling places throughout the county. From left to right are Harry Ballenger, Daniel Gormely, Henry Gartner Jr., Frank W. Woverton, Albert Johns, and Henry Gartner.

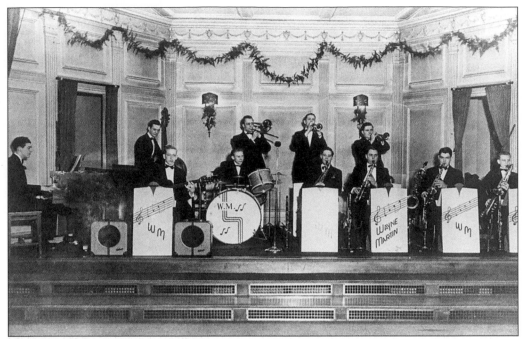

WAYNE MARTIN'S DANCE BAND. The Wayne Martin Band was popular in the Newark area. Above, Wayne Martin's Dance Band is shown in full performance regalia, probably during the 1940s or 50s. Among those identified are: Martin, on drums; Charlie Dowling, on bass; and Delbert Froelich, on saxophone. Below, the Wayne Martin Band, from left to right, are: Billy McArtor, an unidentified Columbus musician, Martin, the late Willis "Whitey" Bishop of Alexandria, an unidentified woman, and Bob Chalfant.

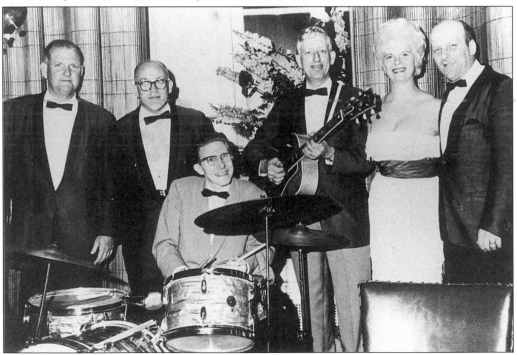

Ten

IDLEWILDE PARK

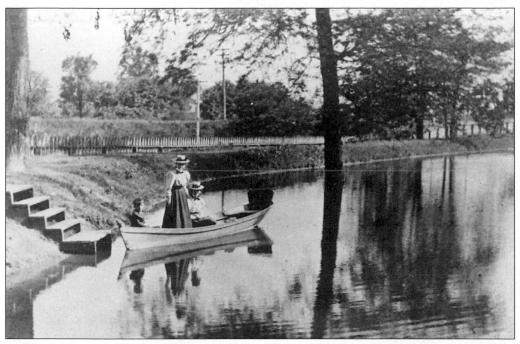

"DREAM LAKE," IDLEWILDE PARK. Light craft carried boating parties during daytime and evenings. Girls with their sailor hats of the Gay Nineties are pictured here ready for a row on the lake. Strolling through what is now known as Moundbuilders Park, one will walk through an area that was once the grand and beautiful Idlewilde Park. Much time and large sums of money were expended in making this park one of the most beautiful and attractive spots in Ohio, a place where the public could find rest, comfort, and amusement combined. Here you would find music, charming scenery, broad waters for boat riding, and amusements of all kinds. The crowning glory of Idlewilde Park was the famous "Old Fort," which constituted a large portion of the park grounds. Four large lakes covered an expanse of seven acres, and were not only picturesque but afforded ample facilities for boating and bathing in the summer, and for skating in the winter. A large and beautiful summer theater was a special attraction of the park. During the season, the best theatrical and musical entertainment was enjoyed at a nominal cost. (Photograph by Chalmers Pancoast.)

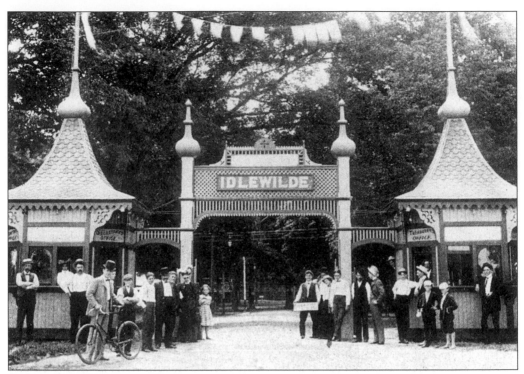

Entrance to Idlewilde Park.

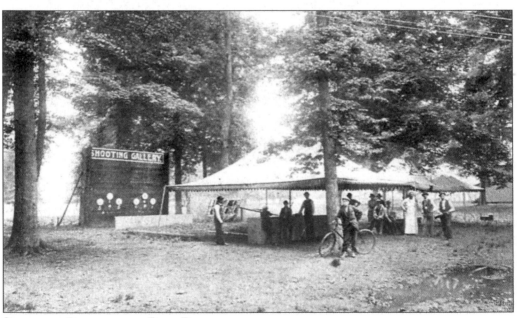

Shooting Gallery and Ball Rack.

122

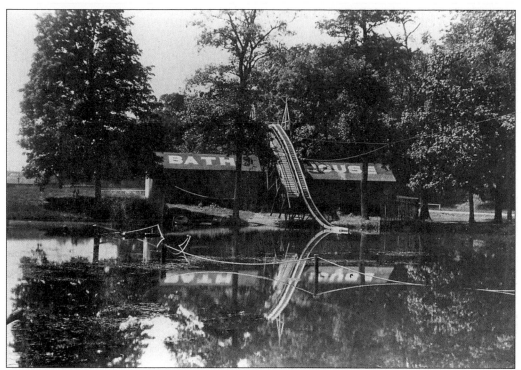

BATH HOUSE.

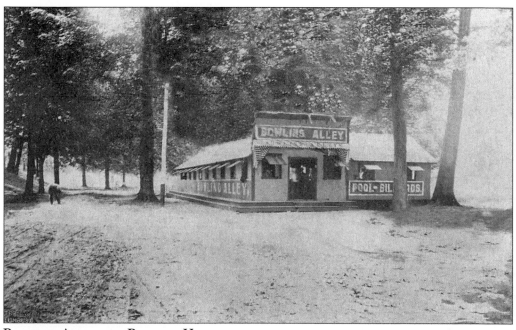

BOWLING ALLEY AND BILLIARD HALL.

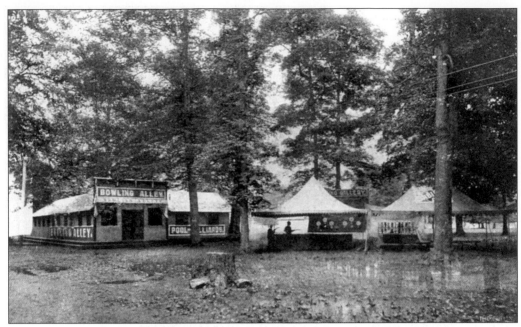

Idlewilde Park Amusements.

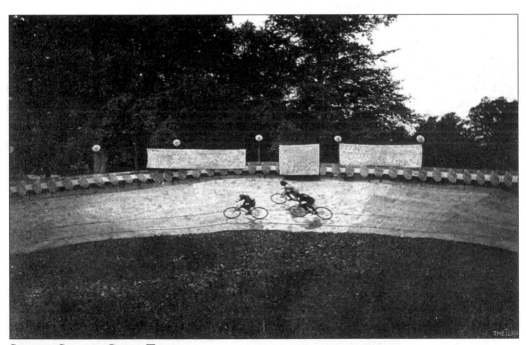

Saucer-Shaped Cycle Track.

RIDING THE SWITCHBACK ON
SMALL CARS.

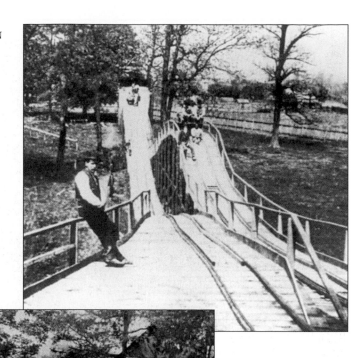

CHECK ROOM AND
SWITCHBACK.

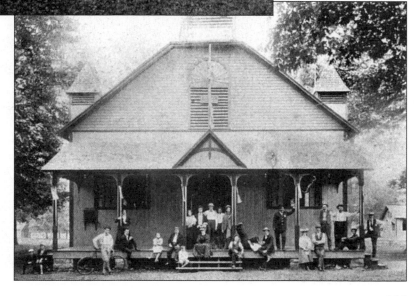

IDLEWILDE PARK
CASINO.

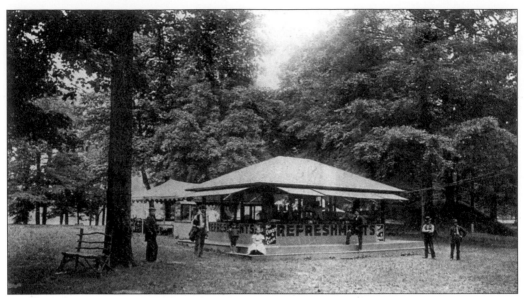

IDLEWILDE PARK REFRESHMENTS STANDS.

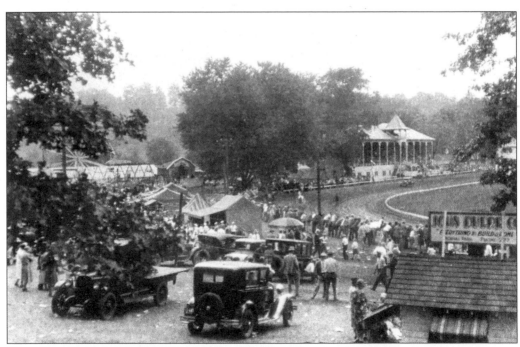

"OLD FORT" GRANDSTAND, 1920 SULKY RACES. (Photograph by Chalmers Pancoast.)

ABOUT THE AUTHOR

Chance Brockway is an avid historian with an extensive collection of historical photographs of Licking County, Ohio. He created a video for the Greater Buckeye Lake Historical Society, *Postcards of Buckeye Lake*, from his extensive collection. He has been a photographer for over 60 years, and no one is responsible for more Ohio State University pictures than this free-lance photographer. The 86-year-old and his lens have followed the Buckeyes since 1956.

Brockway grew up at the Buckeye Lake Amusement Park where his father managed the Lilac Room, the attraction's largest sit-down restaurant. Because two of his father's friends were photographers, Brockway spent his childhood around the equipment, and discovered he had an inborn love of two things: photography and sports. He decided to combine the two. His camera has preserved action at Super Bowls, Major League Baseball games, ABA and NBA contests, and at a number of key sporting events in the Midwest over nearly five decades. The veteran shooter owns negatives of Paul Warfield, Matt Snell, Rex Kern, Archie Griffin, and nearly every All-American from the past 50 years. Many sports photographs have been published in magazines and books including: *Best of the Buckeyes*; *Ohio State: All The Way to the Top*; *I Remember Woody*; *Woody's Boys*; and *ABC Sports College Football All-time All-American Team*. He continues to contribute to a number of books and publications.

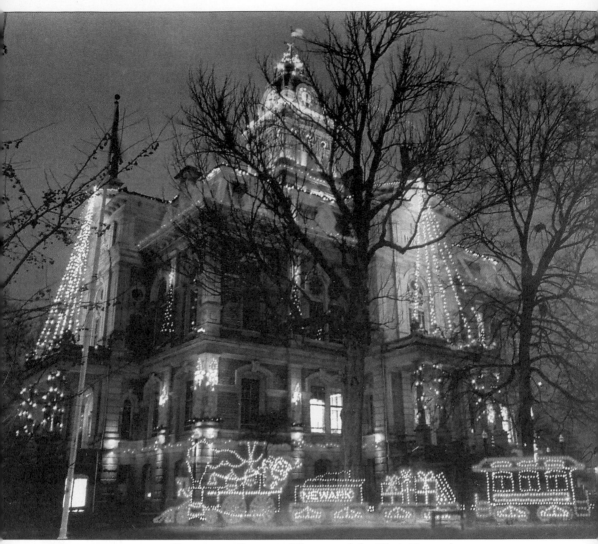

COURTHOUSE WITH CHRISTMAS LIGHTS. (Photograph by Chris Kassen.)